By Good Hands

New Hampshire Folk Art

ROBERT M. DOTY

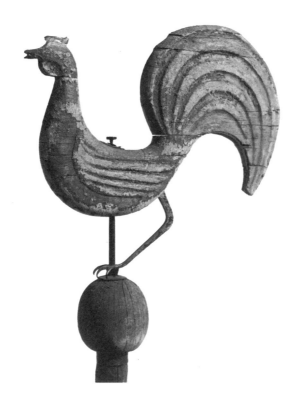

Distributed for The Currier Gallery of Art and the
University Art Galleries, University of New Hampshire,
by the University Press of New England,
Hanover and London.

This catalogue accompanies a cooperative exhibition project of The Currier Gallery of Art, Manchester, New Hampshire, and the University Art Galleries, University of New Hampshire, Durham.

Library of Congress Catalogue Card Number: 89-40358
ISBN 0-87451-973-X

Cover illustration:
Joseph H. Davis (active 1832–1838)
Portrait of Bartholomew Van Dame, 1836
pencil, ink, and watercolor on paper, 10 x 11¼
The Currier Gallery of Art; purchased in honor of Melvin E. Watts

By Good Hands: New Hampshire Folk Art

Exhibition Schedule

The Currier Gallery of Art
Manchester, New Hampshire
June 23 through September 3, 1989

University Art Galleries
University of New Hampshire
Durham, New Hampshire
October 23 through December 10, 1989

Hood Museum of Art
Dartmouth College
Hanover, New Hampshire
March 10 through May 20, 1990

The exhibition and catalogue are supported by grants from Chubb LifeAmerica, Concord, New Hampshire, and the National Endowment for the Arts, a federal agency. Other patrons of the exhibition are listed in the Foreword.

Dimensions of all works are given in inches; height precedes width and depth.

Figures 22, 66, and 67 are shown in Manchester only. Color plates III, IV, and VI and figures 1, 2, 6, 13, 39A–D, 40–43, 45, 51, 55, 61, 62, 73, and 93–95 are not included in the exhibition.

Lenders to the Exhibition

Addison Gallery of American Art, Phillips Academy, Andover, Massachusetts

The Barenholtz Collection

Boscawen Public Library, Boscawen, New Hampshire

The Currier Gallery of Art, Manchester, New Hampshire

Exeter Historical Society, Exeter, New Hampshire

Hank and Dorothy Ford

Fruitlands Museums, Harvard, Massachusetts

Henry Melville Fuller

Heritage Plantation of Sandwich, Massachusetts

Hood Museum of Art, Dartmouth College, Hanover, New Hampshire

Horatio Colony House Museum, Keene, New Hampshire

The Lamont Gallery, Phillips Exeter Academy, Exeter, New Hampshire

Manchester Historic Association, Manchester, New Hampshire

Milford Historical Society, Milford, New Hampshire

Nashua Historical Society, Nashua, New Hampshire

New Hampshire Historical Society, Concord

New York State Historical Association, Cooperstown

Old Sturbridge Village, Sturbridge, Massachusetts

Peterborough Historical Society, Peterborough, New Hampshire

Phillips Exeter Academy Library, Exeter, New Hampshire

Don and Phyllis Randall

Sandwich Historical Society, Sandwich, New Hampshire

Mr. and Mrs. Samuel Shaer

Sugar Hill Historical Museum, Sugar Hill, New Hampshire

Walpole Historical Society, Walpole, New Hampshire

David Bradstreet Wiggins

Contents

Foreword

It is with great pleasure that The Currier Gallery of Art and the University Art Galleries present *By Good Hands: New Hampshire Folk Art* to people throughout the state of New Hampshire. Our state has fostered a long and distinguished history in the production of folk art, a fact that is evident in the works brought together for this exhibition. It is our hope that the exhibition will build on the renewed interest in the folk art and artists of New Hampshire and provide an impetus for the continuation of this strong tradition.

By Good Hands: New Hampshire Folk Art is the fourth in a series of exhibitions organized by the University Art Galleries of the University of New Hampshire exploring the cultural and artistic heritage of the state of New Hampshire. The first three exhibitions focused on the Isles of Shoals (1978), the White Mountains (1980), and the art colonies of Cornish and Dublin (1985). Each of the previous exhibitions was funded in part by grants from the National Endowment for the Arts, and we are pleased that *By Good Hands: New Hampshire Folk Art* has also received a grant from that federal agency.

Appreciation is extended to those who contributed directly to The Currier Gallery of Art in support of *By Good Hands: New Hampshire Folk Art.* Major funding was provided by Chubb Life-America of Concord, New Hampshire. In addition to a grant from the National Endowment for the Arts, individual gifts were received from the late Winthrop L. Carter and from Priscilla C. Murray and her late husband, Albert Murray. Support for a seminar at The Currier was received from the New Hampshire Humanities Council and the Bernard M. Barenholtz Trust.

A number of individuals, organizations, and businesses from the New Hampshire community have provided support for the exhibition and catalogue through their contributions to the University Art Galleries. They include the following: Dr. and Mrs. Peter Beck; John G. Bryer; Dr. and Mrs. Geoffrey E. Clark; Captain and Mrs. Howard S. Crosby; Miss Irene Crosby; Mrs. Storer G. Decatur; Mrs. Elizabeth Delano and the late Warren Delano; Mr. and Mrs. Jameson S. French; Shirley S. French; the Friends of the University Art Galleries; Constance Eaton and William B. Hart, Jr.; Senator Elaine S. Krasker; Phineas of Portsmouth, New Hampshire; Mr. and Mrs. John B. Smith; and Anne Pease Tucker. Support for bringing the exhibition to Durham and the New Hampshire seacoast area has been provided by the Whaleback Fund, the Winthrop L. Carter Fund, and the Winebaum Fund—component funds of the Greater Portsmouth Community Foundation. The generosity and interest of these patrons have enriched the project and contributed to its success.

Initial support for, and interest in, an exhibition on the folk art of New Hampshire came from the late Winthrop L. Carter, president of the Board of Advisors to the University Art Galleries from 1971 to 1981. The exhibition had been suggested by Robert M. Doty, then director of The Currier Gallery of Art, who took on curatorial responsibility for the project. After eleven years of research and exploration of countless private collections, historical societies, and major public museums, he is to be commended for his selection of the finest examples of New Hampshire folk art and for his thoughtful catalogue essay. There are also many individuals at each of our museums who have

contributed to this project, and who deserve special mention: Michael K. Komanecky, Susan Leidy, Timothy A. Johnson, Amanda Preston, Nancy B. Tieken, Catherine A. Wright, Janet Story Clark, Virginia H. Eshoo, Julie A. Solz, Paula M. Paulette, and Alan Grimard and his staff at The Currier; and M. Lora Lytjen, Helen K. Reid, and Margaret Gilman at the University Art Galleries.

We are pleased that the Hood Museum of Art will be participating in the tour of the exhibition, thereby making it available to viewers in the northern and western parts of the state. *By Good Hands: New Hampshire Folk Art*, the first collaborative project between The Currier Gallery of Art and the University Art Galleries, has been beneficial and rewarding for both institutions. We trust that the exhibition and catalogue are concrete proof of a successful collaboration.

Marilyn Friedman Hoffman, Director
The Currier Gallery of Art
Manchester, New Hampshire

Vicki C. Wright, Director
University Art Galleries
University of New Hampshire
Durham, New Hampshire

Contributor's Statement

Chubb LifeAmerica is proud to be associated with *By Good Hands: New Hampshire Folk Art*. By providing major support for this exhibition and the catalogue, the company reaffirms its commitment to the arts and to the people of New Hampshire, whose artistic heritage is so eloquently documented through this project. We congratulate The Currier Gallery of Art and the University Art Galleries, University of New Hampshire, for their achievements in organizing this very important exhibition. We also salute The Currier Gallery at the onset of its sixtieth anniversary celebration this year. We express our gratitude to the museum for the many accomplishments that have marked its history as New Hampshire's premier art museum.

John F. Swope, President
Chubb LifeAmerica
Concord, New Hampshire

Preface

The works of art in this catalogue were chosen primarily for their right to be considered as images and objects endowed with a strong and enduring aesthetic quality. Moreover, they were selected because they are extraordinary examples of art made by creators whose determination to make something beautiful triumphed over a limited knowledge of their chosen media. This art was successful in its own time, and has grown in stature when measured by modern standards. Folk art in New Hampshire was fostered by pragmatism, utilitarian needs, and a fervent desire to make something that aroused the senses. These works have a secure place in the ranks of those artistic achievements that have the authority of excellence generated by the creative act.

All the works in the exhibition and catalogue exist because they were made to realize a purpose. Therefore, they have been grouped in broad categories that suggest the reasons for which they were made. It is important to know that these works of art are the result of need, profit, vanity, prestige, and other social factors. Folk art is rarely extraneous or frivolous. It is conceived in necessity, nurtured by innate skills, and born with exuberance and vitality. It is an integral part of the society in which it is made.

In the process of selection, a high priority was given to those works that are unique in form or content and posed a challenge for their makers. Cigar-store Indians, furniture, most weather vanes, rugs, quilts, samplers, pottery, and toys were not included because, whether manufactured or handmade, they were produced according to a well-known format or standard by someone trained for that specific task and thus do not reflect the vision and skill of an individual artist. An exception to this rule has been made if the work is an excellent example of its kind, but, generally, objects or images of preordained form, although admired for such qualities as highly decorated surfaces or beauty of shape, have been excluded. Although the exhibition and catalogue are comprehensive, neither is definitive. Many works could not be included because of condition, inherent character, or owner reluctance to lend, but are illustrated in the catalogue. Undoubtedly, many important works are still cloaked in obscurity.

A work was considered for inclusion in the exhibition if it was clearly documented as being made in New Hampshire, had a proven history of ownership in New Hampshire, or focused on a subject known to be part of the state and its history. Many pictures and objects had to be excluded because they lacked a history or evidence of having been created within state boundaries. From the beginning, there was no expectation of finding a unique regional style or content, for there is none. The folk art of New Hampshire must be considered a major part of the larger body of work that was produced in the northeastern section of the United States.

The project was intended to provide a sense of the creative spirit that has always been part of life in the Granite State. It is the fourth in a series devoted to the history of art in the state of New Hampshire, planned and executed at the University Art Galleries, University of New Hampshire. *By Good Hands: New Hampshire Folk Art* was realized through grants from Chubb LifeAmerica and the National Endowment for the Arts, with generous gifts from the numerous patrons listed in the Foreword, and warmest appreciation is extended to these donors. The initial planning was encouraged and supported by the late Winthrop L. Carter and Susan Faxon, then director of the University Art Galleries.

The directors and staffs of the participating institutions have been very helpful, particularly Vicki C. Wright of the University Art Galleries; Marilyn F. Hoffman and Amanda Preston of The Currier Gallery of Art; and Richard Tietz, Jacquelyn Baas, and Timothy Rub of the Hood Museum of Art, Dartmouth College. Mary-Leigh Smart and the members of the Board of Advisors to the University Art Galleries have been a source of constant and interested assistance.

Many individuals shared their resources, time, information, and expertise. They are Henry and Elizabeth Andrews; Barbara Austen; Bernard M. Barenholtz; Alice M. Bodine; Mr. and Mrs. Charles Cobb; Virginia Colby; George Comtois; Christopher C. Cook; Brian Cullity; John O. Curtis; Paul S. D'Ambrosio; Mrs. Elizabeth Delano; Ellen Derby; Edouard L. Desrochers; Paul Doty; Mr. and Mrs. Daniel Farber; Bill Finney; Faith Flythe; Linda M. Frawley; John Frisbee; Henry Melville Fuller; James W. Griswold; Maryanna Hatch; Agnes Halsey Jones; Dr. Louis C. Jones; Richard Kathman; Mrs. Norma Lewis; Mrs. Nina Fletcher Little; Warren Little; William Lyman; Barbara MacAdam; A. Bruce MacLeish; Mrs. Nancy C. Merrill; Robert Miner; Nancy C. Muller; Mrs. Suzita Myers; Chester Newkirk; David Ottinger; Richard Peloquin; Mrs. Heather Pentland; Don and Phyllis Randall; Richard Reed; Roland Sallada; Gary Samson; Mrs. Dorothy Sanborn; Bert Savage; Mrs. Stella J. Scheckter; David A. Schorsch; Gene A. Schott; Theodore E. Stebbins, Jr.; John F. Swope; Nicki Thiras; Mitchell and Jane Vincent; Gerald W. R. Ward; David Bradstreet Wiggins; and Bill and Judy Wolfe.

Robert M. Doty
Guest Curator

Commemoration

Before 1750, the role of the artist in America was limited. Trade and the production of goods and crops engrossed most colonists, while the foundation was laid for a new social hierarchy of wealthy merchants. After the War of Independence, the growth of commerce accelerated, and urban seaports became the place for a display of wealth and power. By 1800, mansions in the Federal style began to appear as coastal towns became markets for the timber and crops of the adjacent hinterlands. Massive commercial buildings of brick and stone were also erected to house the government officials, and others, who monitored trade and looked after the interests of a new mercantile and professional elite.

Opportunities for the artist increased steadily. There was little differentiation between "fine" art and more practical forms. Isolation and scarcity forced every person to be a capable technician. The artist had to be ready to paint signs, houses, furniture, carriages, fireboards, fire buckets, and military and political banners. Labor was valued, even exalted, as part of good social behavior. The new democratic society placed great faith in ability, cleverness, and hard work, all or one of which might lead to advancement in social standing. More often than not, necessity was the reason for making art, but there was a demand for embellishment with color and line as well. Artists regarded their job and products as they would if employed in any other trade, and they approached each task as would the mason or cabinet maker, working piece by piece, one segment following another until the whole was complete. That art was a matter of skill, work raised to a higher standard, was not a conscious attitude, but rather an unquestioned assumption.

The inherent problems of the trade were met with stoic determination. To find new clients, the artists of New Hampshire, like others of that time, traveled extensively to accommodate their clientele. Zedekiah Belknap, for example, moved constantly through Vermont, New Hampshire, and Massachusetts during a career that lasted nearly forty years. The dates on the works attributed to Joseph H. Davis indicate a much shorter career, and he confined his travels to eastern New Hampshire and southern Maine.

The need to create was not diminished by the artists' restricted access to formal and thorough training in America. A number of colleges, academies, and seminaries had been established by the late eighteenth century, but instruction in the fine arts was still limited. Although Zedekiah Belknap graduated from Dartmouth College, the source of his training as an artist remains a mystery. Instruction manuals (books describing theories and methods for creating an image on a two-dimensional surface) and prints (both European and American) were becoming more available. Many artists learned their technique by seeking the guidance of a more experienced artist, if one was available. Whether trained or self-taught, the artist, charged with both capturing a good likeness and perpetuating the semblance of the subject's self-worth, emulated the artists of Europe. Portraiture in early America was derived from English, Dutch, and Flemish models, which generally emphasized the affluence and rank of the subject rather than personality traits. The problems of being an artist in America were formidable, but many found that improvisation was the way to

success. Unhindered by conventions and traditions, they were free to create their own solutions to pictorial problems.

As the nineteenth century began, the growing number of would-be artists in America relied on intuitive choices and decisions which became the foundation of unique personal visions and styles. The works of Joseph H. Davis and Ruth Henshaw Bascom are particularly fine examples. The encounter with reality was a starting point for the creative process. Although self-taught artists often lacked the ability to describe their subjects with precision and accuracy, they had the freedom to concentrate on what they chose to be visually important. Vanishing point perspective, the modeling of hands and faces, and the infinite variety in the hues and tones of color were beyond them, but they met the problems with innovative and often singular solutions. Unable to render an illusion of depth on a two-dimensional plane, they depended heavily on the basic qualities of color, line, and shape. The human figure, as a form in space, was painted or drawn with simplified, planar shapes, intensified color, and strong outlines, essentially an arrangement of line and areas of flat color. As a result, the image was often distorted and awkward.

Self-confidence must have helped, and the rare chance to see work by other artists or a new instruction manual certainly provided opportunities for improvement. While working in certain stylistic conventions, each artist developed a personal method. The outcome was a range of highly individualistic solutions. Zedekiah Belknap disguised his inability to achieve a life-like image of the human body by using strong colors and dressing his subjects in lavish costumes. The portraits of Ruth Henshaw Bascom and Joseph H. Davis were based on the technique for making portraits in profile, in which the silhouette of a face is traced on paper and then cut from the sheet. Little is known about Ezra Woolson of Fitzwilliam, New Hampshire, but the window-like view of a village street in the background of his portrait of Dr. Smith (figure 14) indicates that he had seen portraits that used a similar convention to provide information about the subject. Horace Bundy and Charles H. Granger effected a steady evolution in style and eventually produced portraits equal in many respects to those which, by their fidelity to the real appearance of the subject, were considered to be the finest of their day.

To complement their grand houses and elegant furnishings, the wealthy merchants and landowners turned to portraiture as a means of securing social franchise. Magistrates, ministers, and merchants commissioned artists such as John Brewster, Jr., Zedekiah Belknap, Joseph H. Davis, and Horace Bundy to create images which not only commemorated their presence on earth but also served as icons of their social status. In due course, the burgeoning middle class of tradesmen and professionals used the portrait as a means of confirming their own aspirations and desire for recognition and identity. The residents of New Hampshire were no exception. Abel Bellows (figure 3) was a founder of the town of Walpole. Levi Jones (figure 4) was a representative to the General Court in Concord who owned land and a tavern.

Dr. Jesse Kittredge Smith (figure 14) and Dr. William Perry (figure 28) served the towns of Mont Vernon and Exeter, respectively. Bartholomew Van Dame (figure 19) was both a teacher and a man of the church who wrote his own funeral sermon and hymn. Mark Demeritt (figure 20) was a magistrate, selectman, and member of the state legislature. Azariah Caverly (figure 21) was a farmer and commander of the Strafford Light Infantry.

By the middle of the nineteenth century, portraiture had become part of the American infatuation with democracy. For years, only the rich and powerful could commemorate their personal aura of rank and privilege. Now, anyone who could pay the price became immortal. The escape from anonymity could be accomplished by sitting for a portrait, which would serve both as a personal record for family and friends and as validation of ascension to a higher social rank. Particularly with the introduction of photography, portraiture became a thriving business for some and the prerogative of all.

There were other means of commemoration, including the tombstone, the mourning picture, and the family record. Each was based on a familiar pattern, which consisted of specific forms and a standard format for conveying information. However, their makers often embellished each work or found new ways to use old symbols and pictorial devices. The men who carved tombstones worked with a consistent repertoire of symbols for life and death, but some carvers developed very personal ways of depicting the human figure. By using lines and geometric forms to signify human features,

these sculptors anticipated the introduction of abstraction in the art of the twentieth century.

The mourning picture appeared in the dawn of the nineteenth century, inspired by the national feeling of grief that followed the death of George Washington. Painted on paper or stitched in fabric, probably by a family member or friend, the image demanded figures attendant on a grave adorned with urns and shaded by a willow tree. The picture could commemorate a single death or a greater tragedy, as does the *Memorial to the Children of Samuel and Elizabeth Morison,* all of whom were deaf-mutes (figure 31).

For those who could not afford the cost of a portrait, there were records of family history—births, deaths, marriages—drawn on paper and embellished in the manner of French and German medieval manuscripts. This work was done by men and women proficient in calligraphy, a manual skill highly valued in the nineteenth century. The art of putting pen to paper could be learned through writing classes that were available in many schools and through instruction books. Most records were unsigned by the maker, but Moses Connor, Jr., was careful to identify his work (figures 33, 34, 35). A school teacher who lived in central New Hampshire towns, Connor created images that combined essential information with a harmony of bird and floral designs.

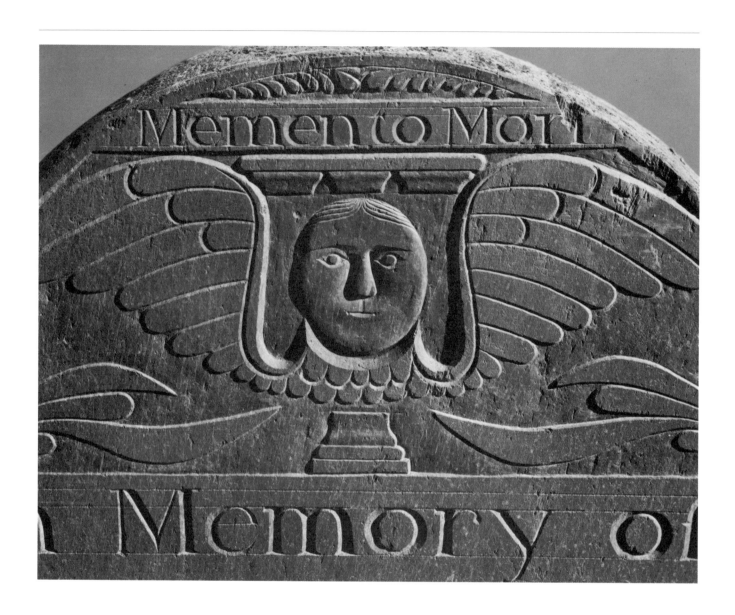

1.
Attributed to the Chesterfield Carver
Detail of a Gravestone for Reuben Graves, 1786
slate, 25 x 20 x 3
Center Burying Ground, Chesterfield, New Hampshire

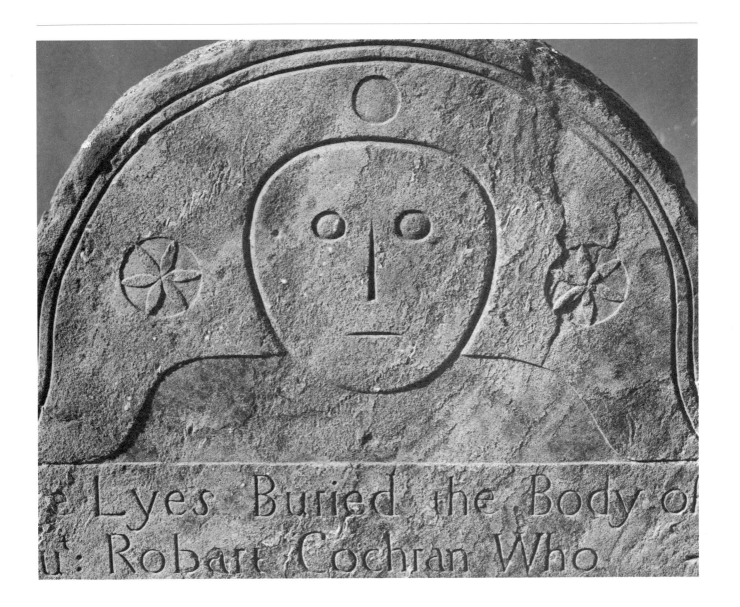

2.
Artist unknown
Detail of a Gravestone for Robart Cochran, 1752
stone, 24 x 20 x 3
Cemetery, East Derry, New Hampshire

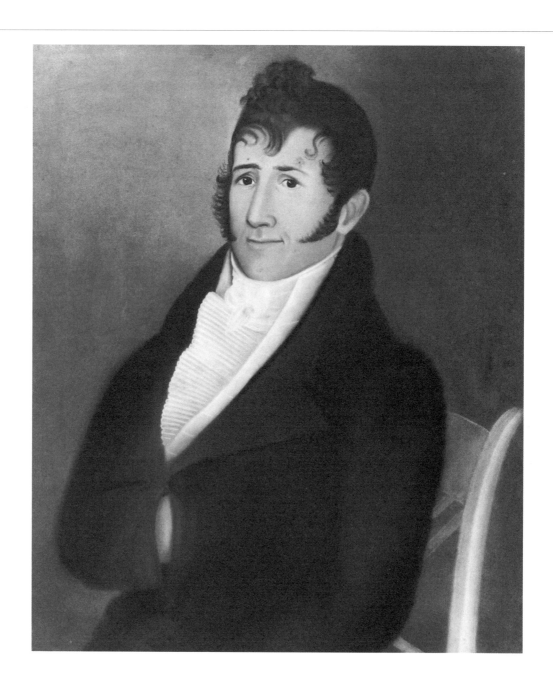

3.
Artist unknown
Portrait of Abel Bellows, c. 1820
pastel on paper, 27 x 23½
Walpole Historical Society; gift of Gladys Bellows Durgin Brown

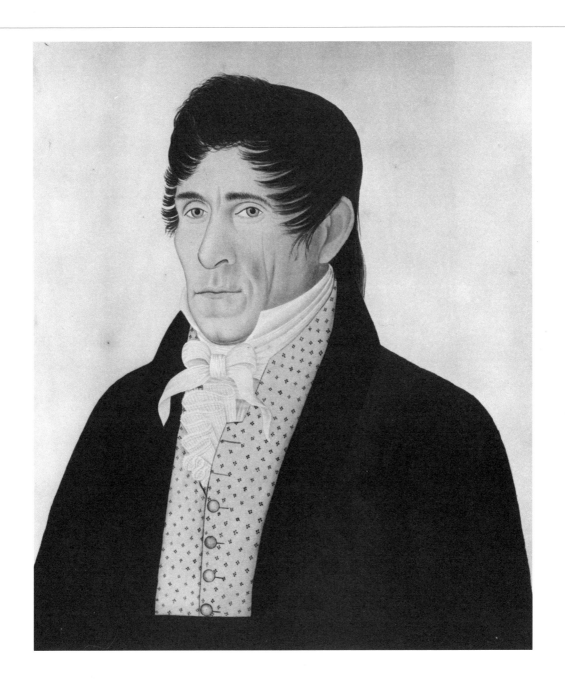

4.
Mr. Willson (dates unknown)
Portrait of Levi Jones, c. 1825
watercolor on paper, 22¾ x 19¼
The Currier Gallery of Art, Manchester, New Hampshire;
gift of Miss Elizabeth Jones

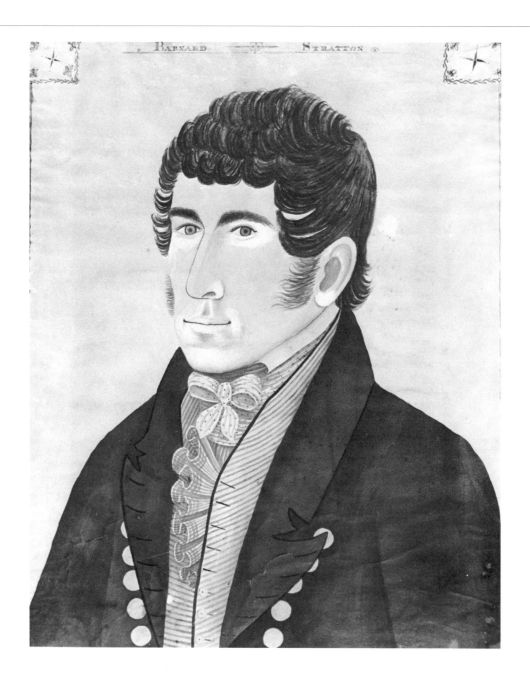

5.
Mr. Willson (dates unknown)
Barnard Stratton, 1822
watercolor and ink on paper, 19½ x 15
New York State Historical Association, Cooperstown

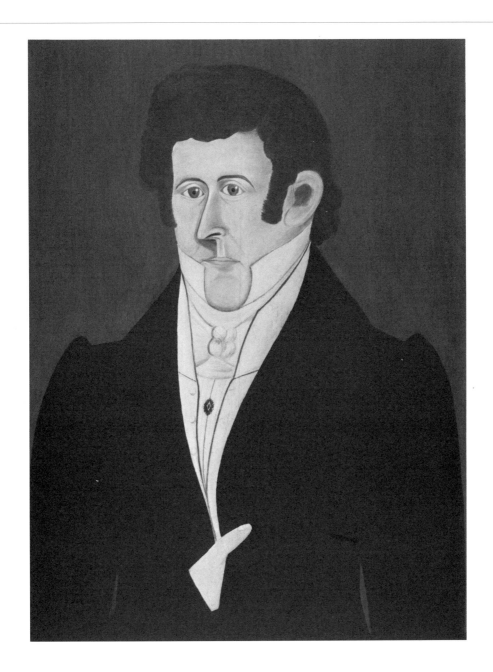

6.
Attributed to A. Ellis (dates unknown)
Mr. Tiffin of East Kingston, New Hampshire, c. 1820
oil on wood panel, 26 x 19¼
Museum of Fine Arts, Boston;
gift of Edgar William and Bernice Chrysler Garbisch

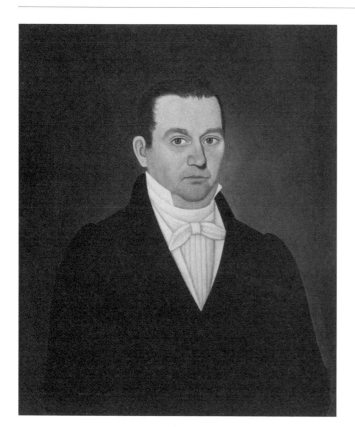 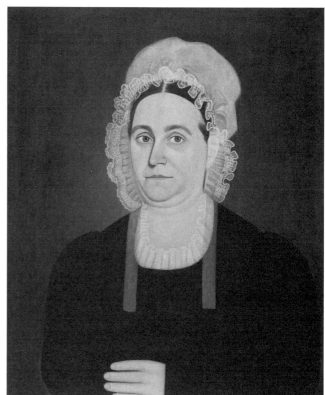

7. and **8.**
Attributed to John Brewster, Jr. (1766–1854)
John Colley and *Martha Colley,* c. 1820
oil on canvas, 30⅜ x 25¼ and 30¼ x 25
Hood Museum of Art, Dartmouth College, Hanover, New Hampshire;
gift of the Estate of Lydia G. Hutchinson, wife of Paul L. Hutchinson, Class of 1920

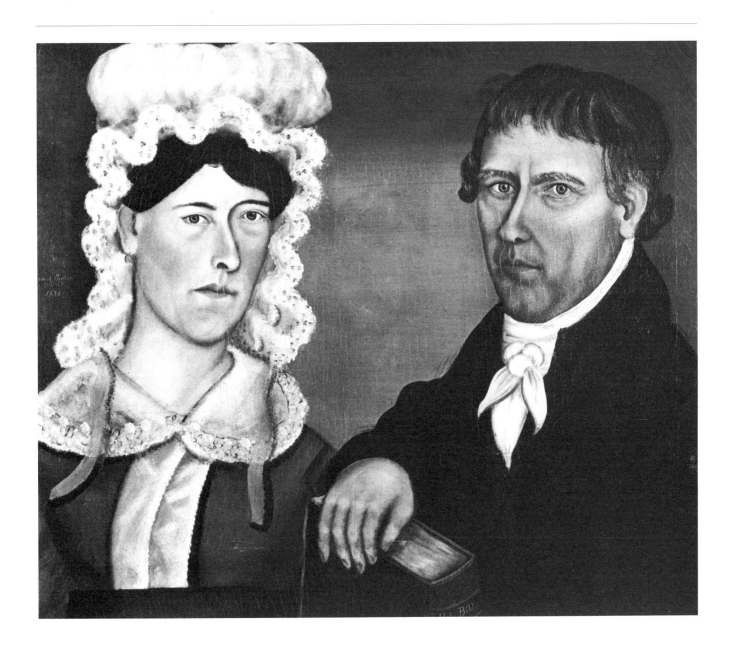

9.
Samuel Jordan (1803—after 1831)
Man and Woman Holding Bible, 1831
oil on canvas, 23 x 28½
New York State Historical Association, Cooperstown

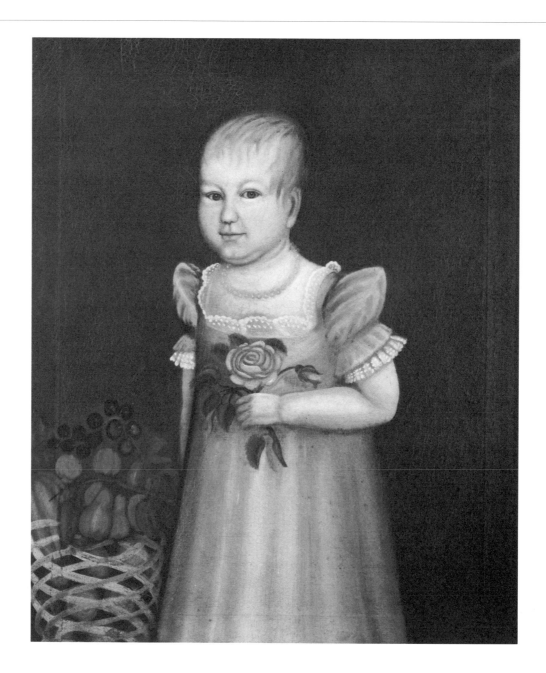

10.
Attributed to Zedekiah Belknap (1781–1858)
Portrait of Mary Ann Riddle, c. 1825
oil on canvas, 26 x 21⅞
The Currier Gallery of Art, Manchester, New Hampshire;
purchased in honor of Robert M. Doty

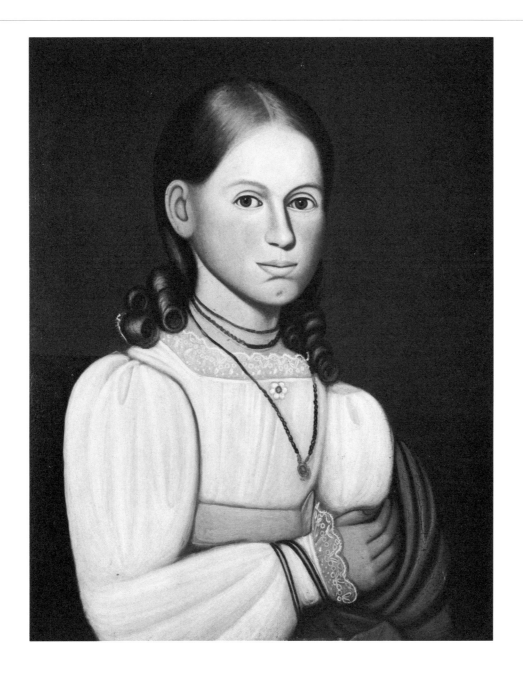

11.
Zedekiah Belknap (1781–1858)
Sarah Minot Melville French, c. 1830
oil on wood panel, 26 x 20
Collection of Henry Melville Fuller

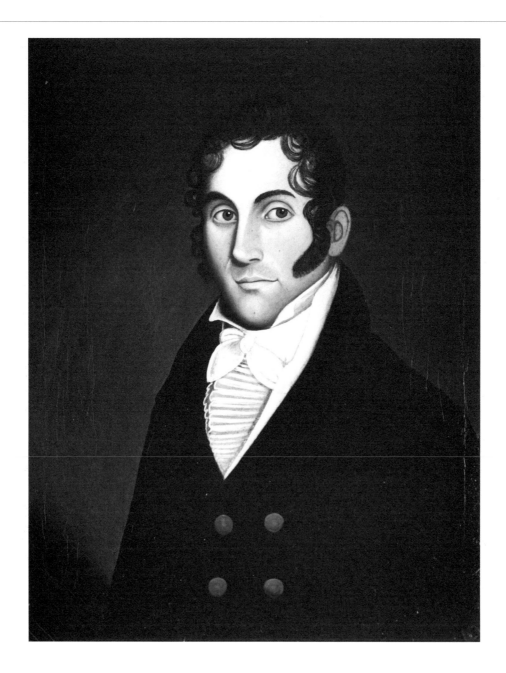

12.
Zedekiah Belknap (1781–1858)
Portrait of Alfred Greeley, c. 1840
oil on canvas, 26 x 20
Nashua Historical Society; gift of the Nashua Public Library

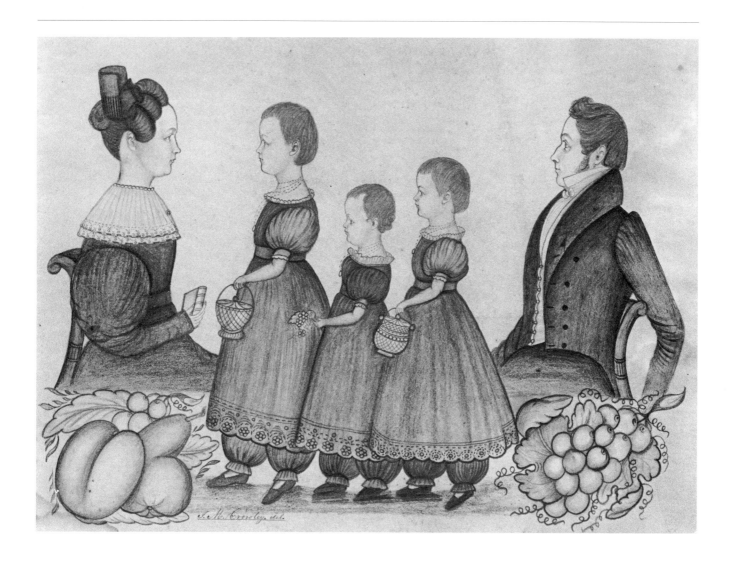

13.
J. M. Crowley (dates unknown)
The Paine Family, c. 1835
graphite on paper, 8 x 11
Private Collection (photograph courtesy of David A. Schorsch, Inc.)

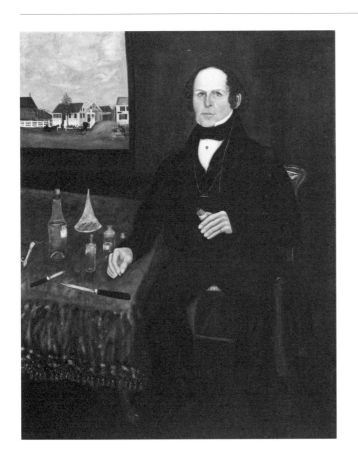 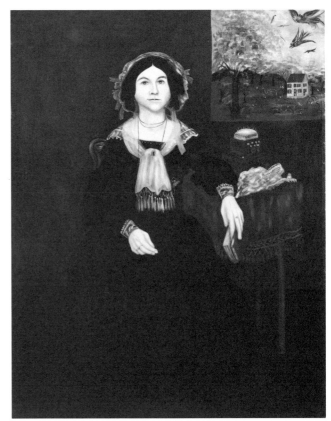

14. and **15.**
Ezra Woolson (dates unknown)
Dr. Jesse Kittredge Smith and ***Pamela Foster Smith,*** 1842
oil on canvas, 60½ x 48½ (each)
Old Sturbridge Village

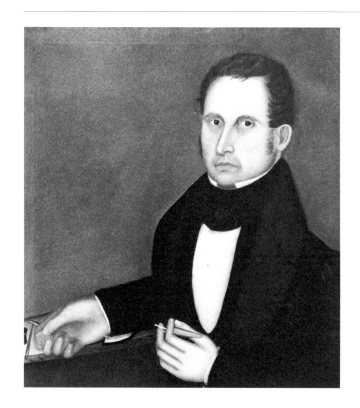
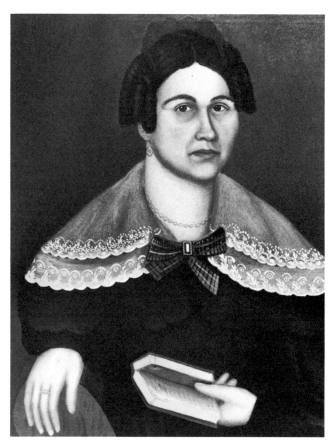

16. and **17.**
Horace Bundy (1814–1883)
N. S. Goddard, Watchmaker, and ***Mrs. Goddard*** (detail), 1837
oil on canvas, 28 x 26 (each)
Heritage Plantation of Sandwich, Massachusetts

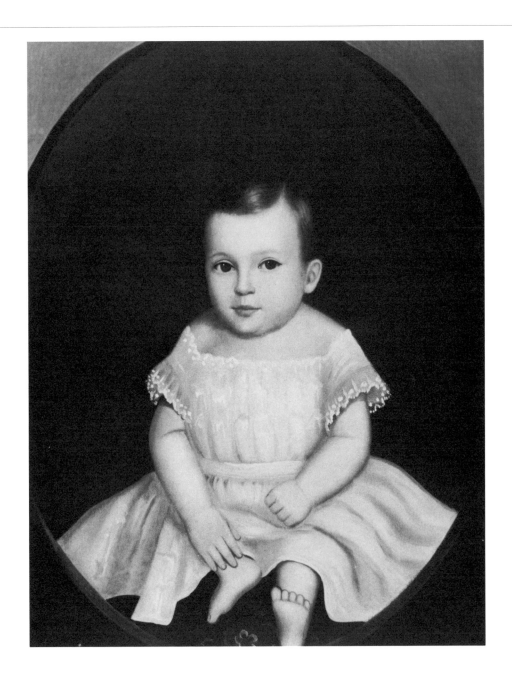

18.
Horace Bundy (1814–1883)
Portrait of a Child, 1850
oil on canvas, 27¼ x 22¼
Collections of the Fruitlands Museums, Harvard, Massachusetts

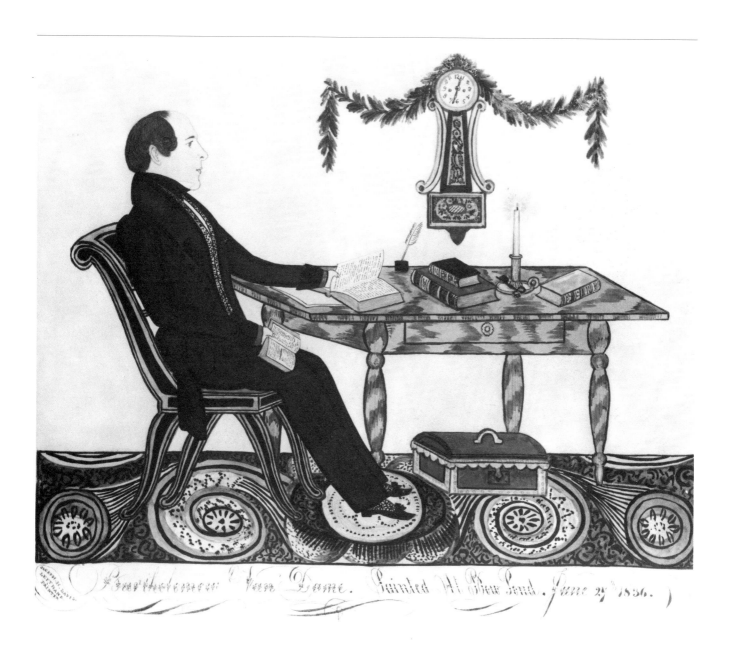

19.
Joseph H. Davis (active 1832–1838)
Portrait of Bartholomew Van Dame, 1836
pencil, ink, and watercolor on paper, 10 x 11¼
The Currier Gallery of Art, Manchester, New Hampshire;
purchased in honor of Melvin E. Watts

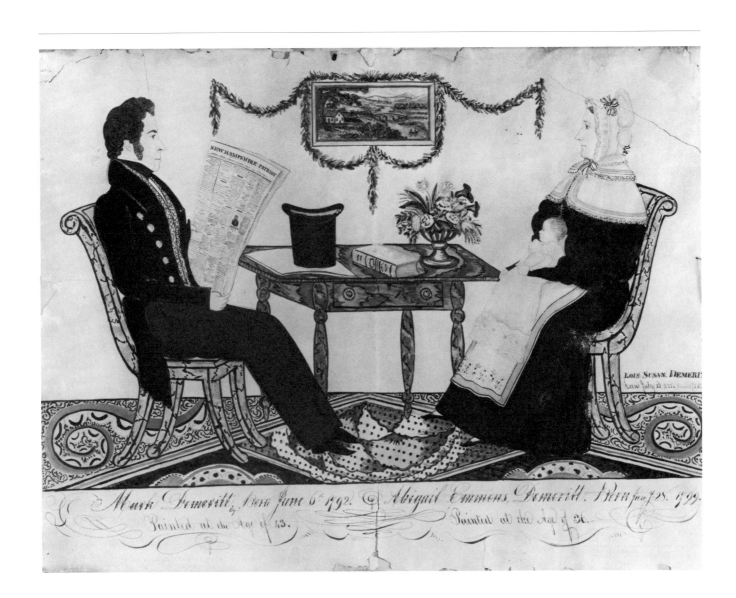

20.
Joseph H. Davis (active 1832–1838)
Portrait of Mark, Abigail, and Lois Susan Demeritt, 1835
pencil, ink, and watercolor on paper, 12 x 16¼
The Currier Gallery of Art, Manchester, New Hampshire;
gift of the Friends

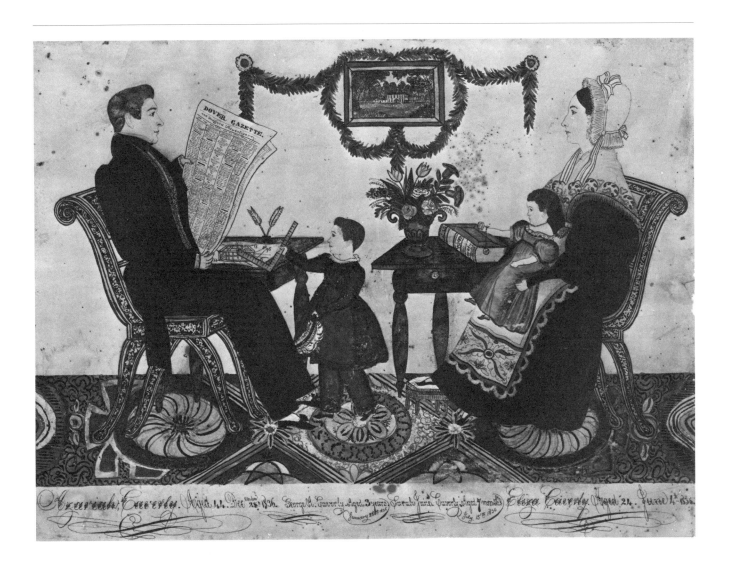

21.
Joseph H. Davis (active 1832–1838)
The Azariah Caverly Family, 1836
pencil, ink, and watercolor on paper, 10¹⁵⁄₁₆ x 14¹⁵⁄₁₆
New York State Historical Association, Cooperstown

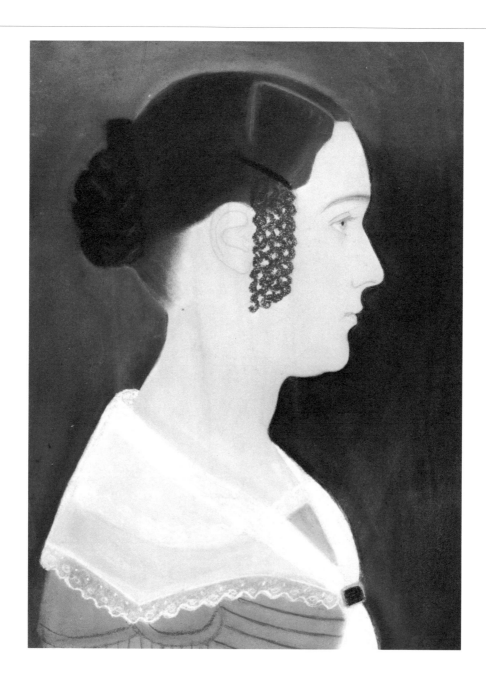

22.
Ruth Henshaw Bascom (1772–1848)
Cynthia Allen, c. 1840
pastel and graphite on paper, 19¼ x 11¼
The Barenholtz Collection

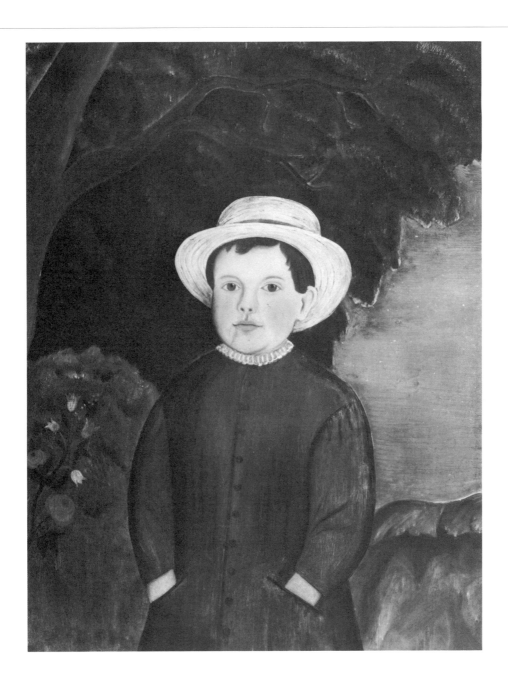

23.
Artist unknown
Portrait of Elisha Marston, c. 1840
oil on wood panel, 29 x 23
Sandwich (New Hampshire) Historical Society

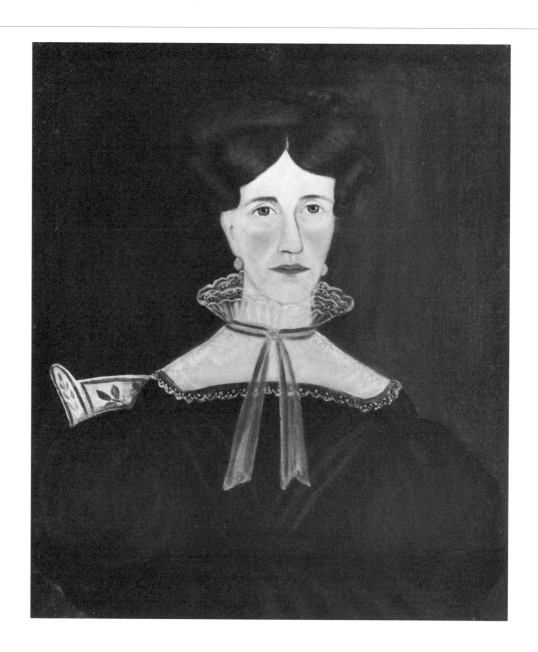

24.
Ruth Whittier Shute (1803–1882) and
Dr. Samuel Addison Shute (1803–1836)
Portrait of Sarah Whitmarsh, 1833
oil on canvas, 30⅛ x 26
The Currier Gallery of Art, Manchester, New Hampshire;
gift of James and Barbara Crosby Enright

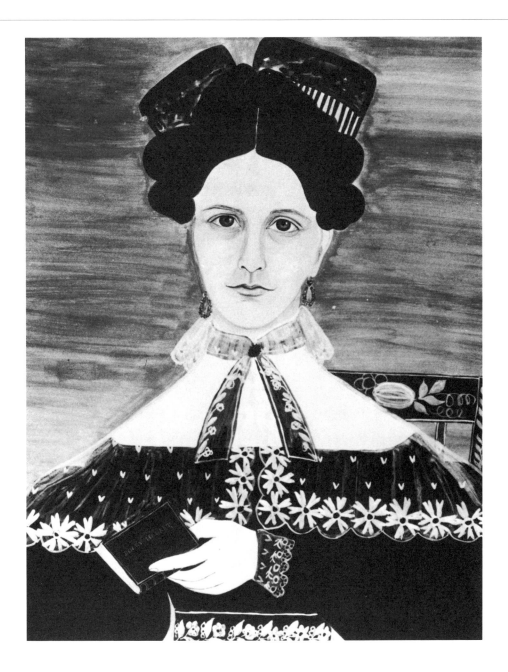

25.
Ruth Whittier Shute (1803–1882) and
Dr. Samuel Addison Shute (1803–1836)
Portrait of Dolly Hackett, 1832
watercolor on paper, 23¼ x 19
Collections of the Fruitlands Museums, Harvard, Massachusetts

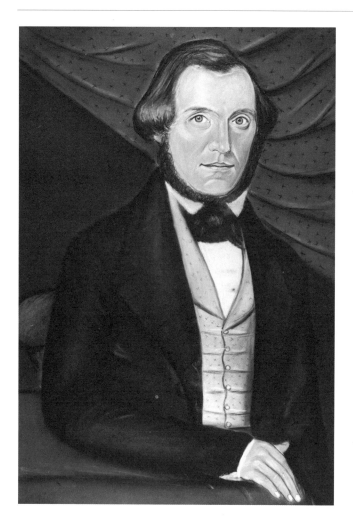 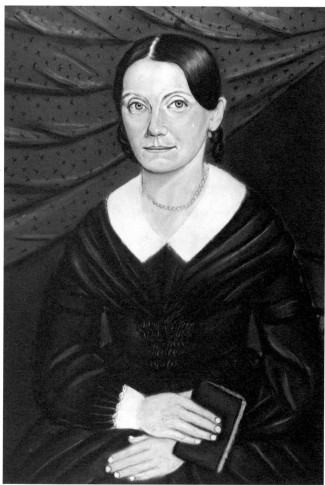

26. and **27.**
Attributed to J. Bailey Moore (active 1840–1880)
Portrait of a Man and *Portrait of a Woman,* c. 1850
pastel on paper, 28¾ x 20½ (each)
Collections of the Manchester Historical Association;
gift of the Manchester Police Department

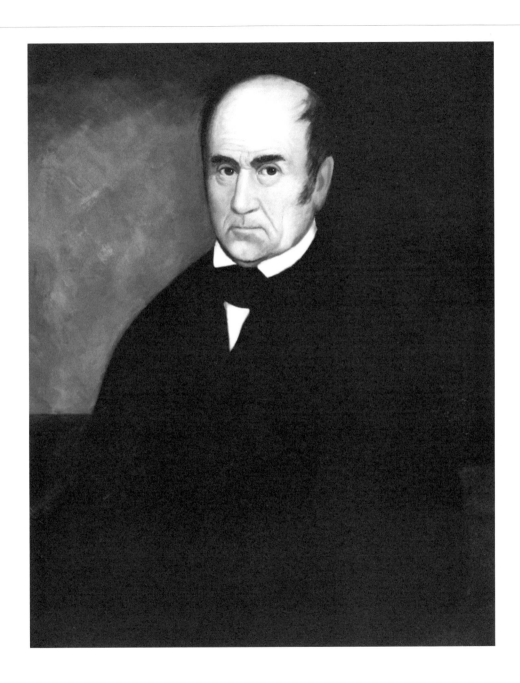

28.
Artist unknown
Portrait of William Perry, M.D., c. 1850
oil on board, 32¼ x 26
Exeter Historical Society; gift of Mrs. Marika Dudley

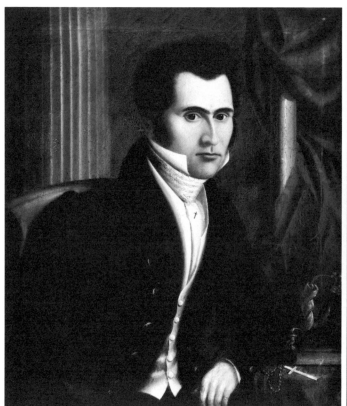 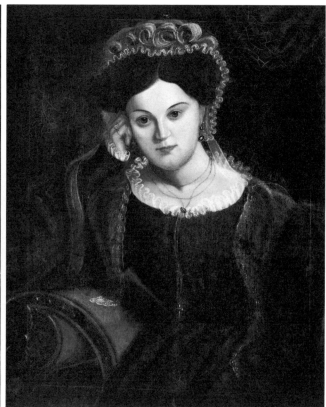

29. and **30.**
Charles H. Granger (active 1830–1870)
Henry Bowen Clark Greene and ***Elizabeth Hartley Greene,*** 1830
oil on canvas, 33 x 29 and 33 x 27½
Collection of David Bradstreet Wiggins

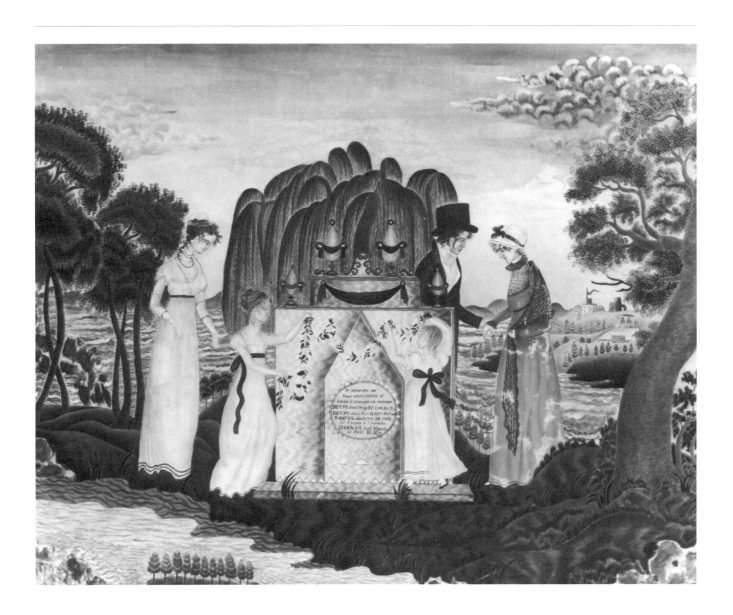

31.
Artist unknown
Memorial to the Children of Samuel and Elizabeth Morison, c. 1812
watercolor on silk, 21½ x 26
Peterborough Historical Society, Peterborough, New Hampshire

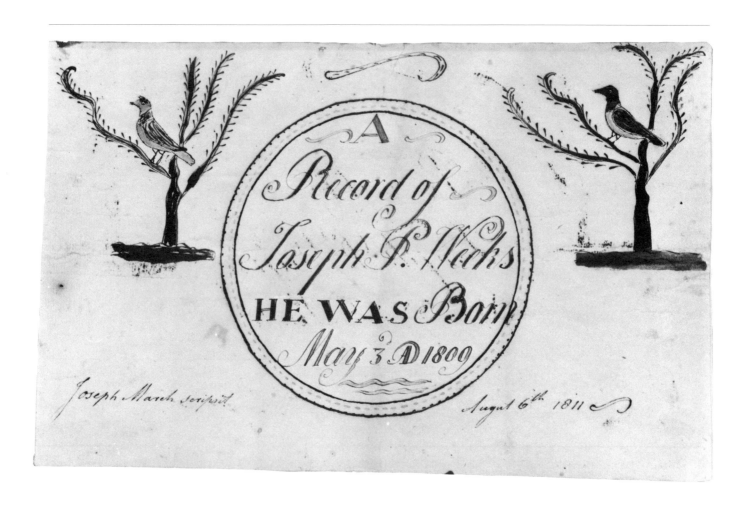

32.
Joseph March (dates unknown)
Birth Record of Joseph P. Weeks, 1811
ink and watercolor on paper, 6¼ x 10¼
Phyllis Randall Collection; courtesy of Strawbery Banke, Inc.

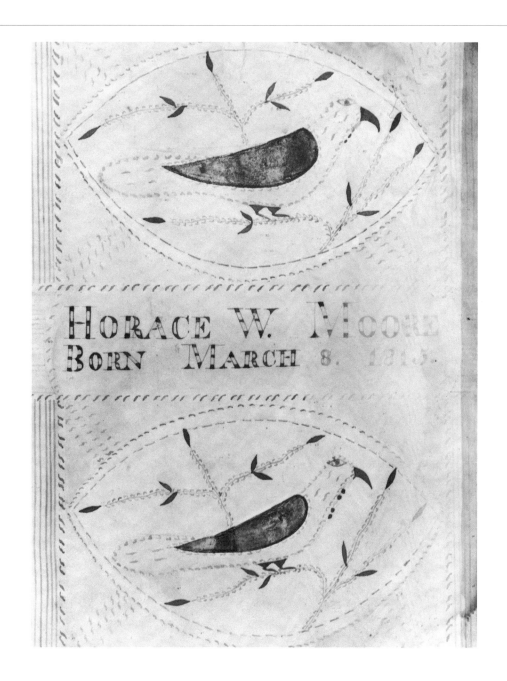

33.
Moses Connor, Jr. (active 1800–1832)
Birth Record of Horace W. Moore, c. 1815
ink and watercolor on paper, 8 x 6
New Hampshire Historical Society

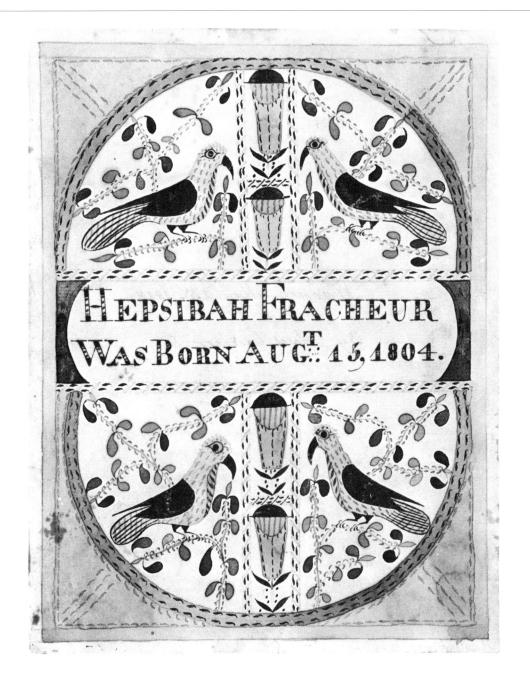

34.
Moses Connor, Jr. (active 1800–1832)
Birth Record of Hepsibah Fracheur, 1818
ink and watercolor on paper, 9 x 7
Old Sturbridge Village

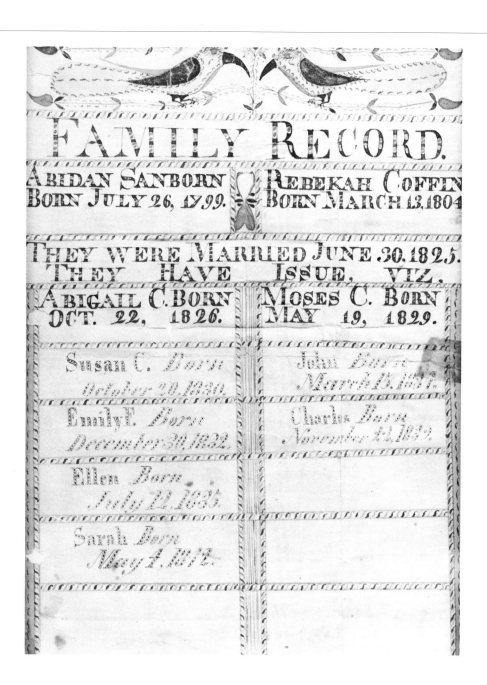

35.
Moses Connor, Jr. (active 1800–1832)
Family Record: Abidan Sanborn–Rebekah Coffin, 1829
ink and watercolor on paper, 11¾ x 8½
Collection of Hank and Dorothy Ford

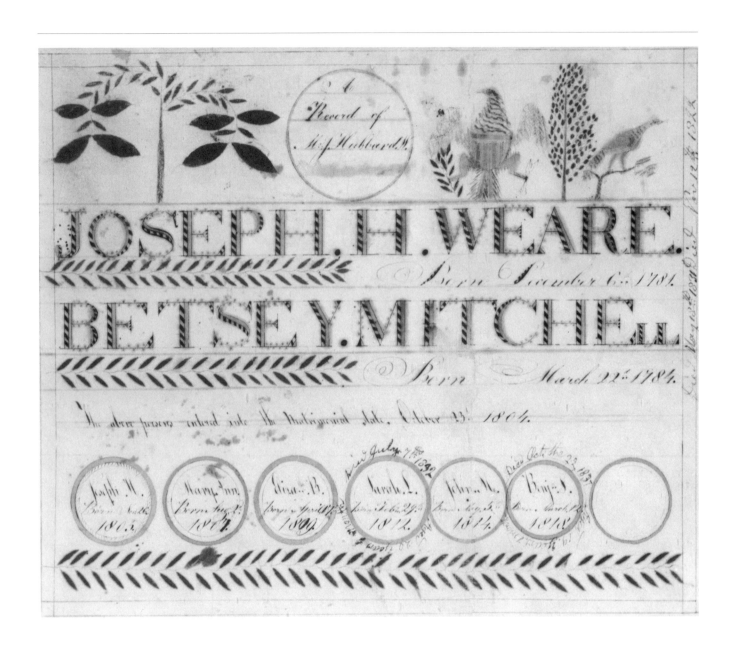

36.
Artist unknown
Family Record of Joseph H. Weare, c. 1820
ink on paper, 9½ x 11
New Hampshire Historical Society

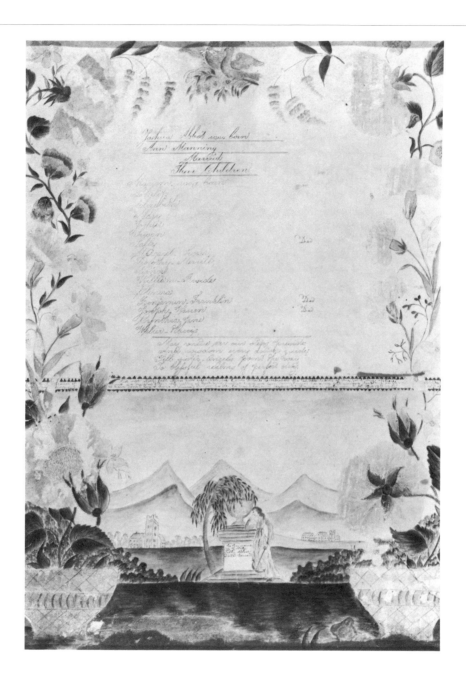

37.
Artist unknown
Family Record of Joshua Abbot, c. 1830
ink and watercolor on paper, 13½ x 9½
New Hampshire Historical Society

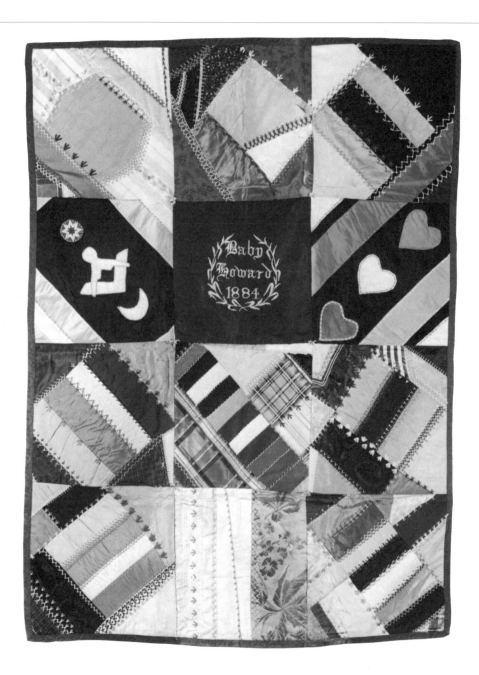

38.
Arlette Hathaway Howard (1840–1889)
Quilt, 1884
various fabrics, 74 x 46
The Currier Gallery of Art, Manchester, New Hampshire;
gift of Mrs. Melvin E. Watts

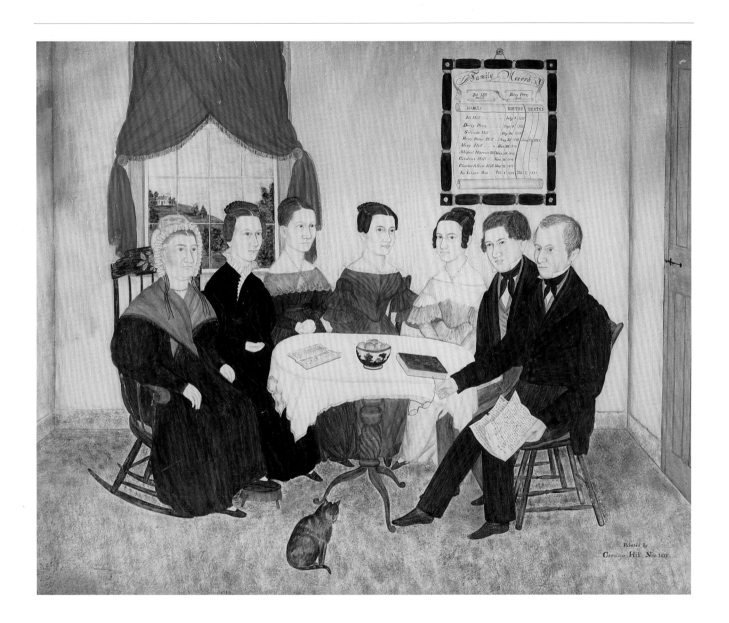

I.

COMMEMORATION
Caroline Hill (dates unknown)
Portrait of Job Hill and His Family, 1837
watercolor and graphite on paper, 11½ x 15
Peterborough Historical Society, Peterborough, New Hampshire

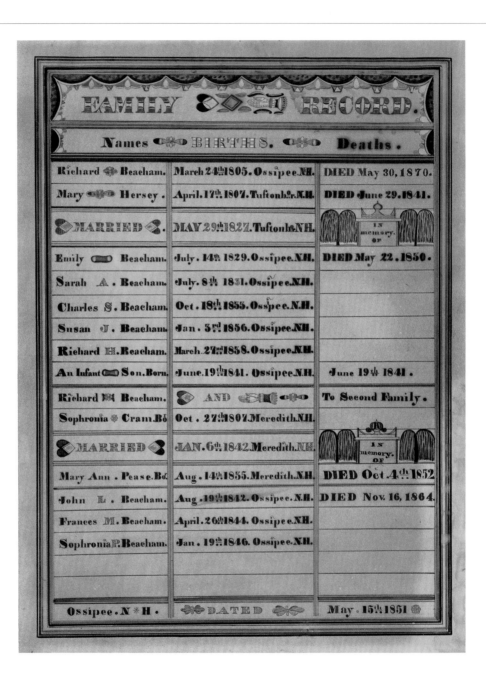

II.
COMMEMORATION
Artist unknown (active 1830–1855)
Beacham Family Record, 1851
watercolor on paper, 15½ x 11¾
Museum of Fine Arts, Boston; M. and M. Karolik Collection

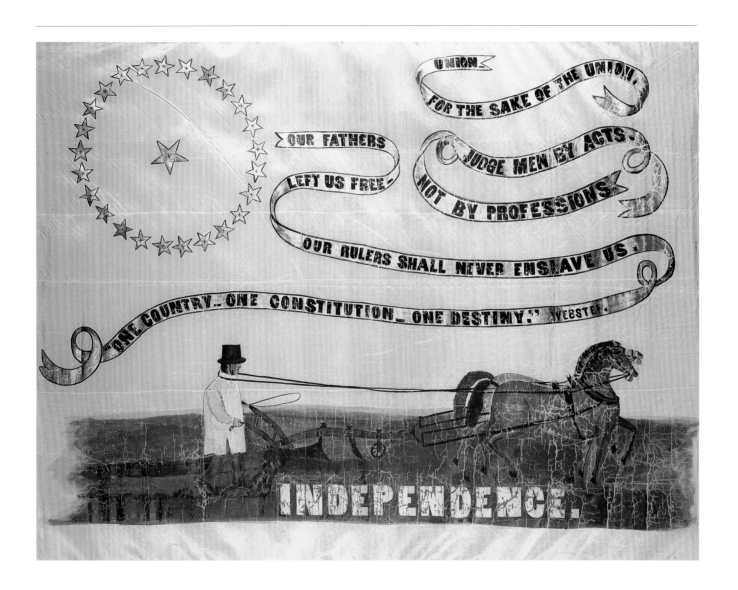

III.
COMMUNICATION
Artist unknown
Campaign Banner for the Whigs of Lyme, New Hampshire, 1840
oil on silk, 54 x 69
Hood Museum of Art, Dartmouth College, Hanover, New Hampshire;
gift of Mrs. Caroline W. Cameron

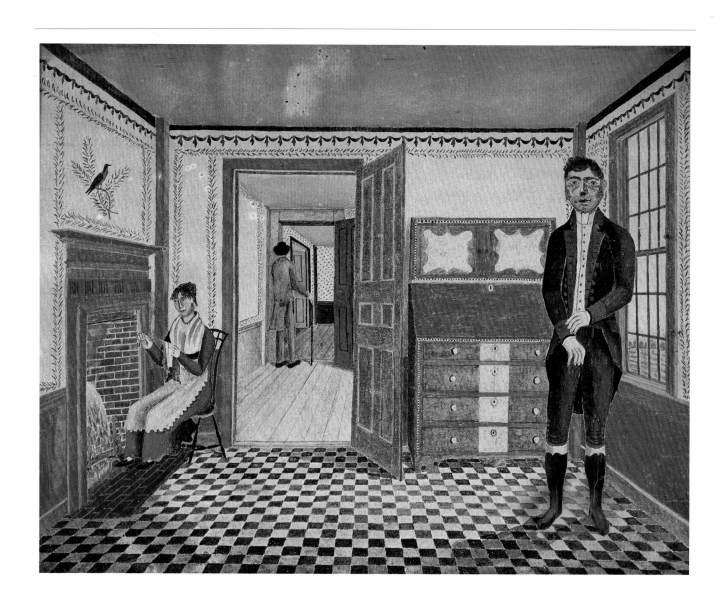

IV.
DOCUMENTATION
Joseph Warren Leavitt (dates unknown)
Lafayette in the Leavitt Tavern, 1824
watercolor on paper, 7 x 9
Private Collection

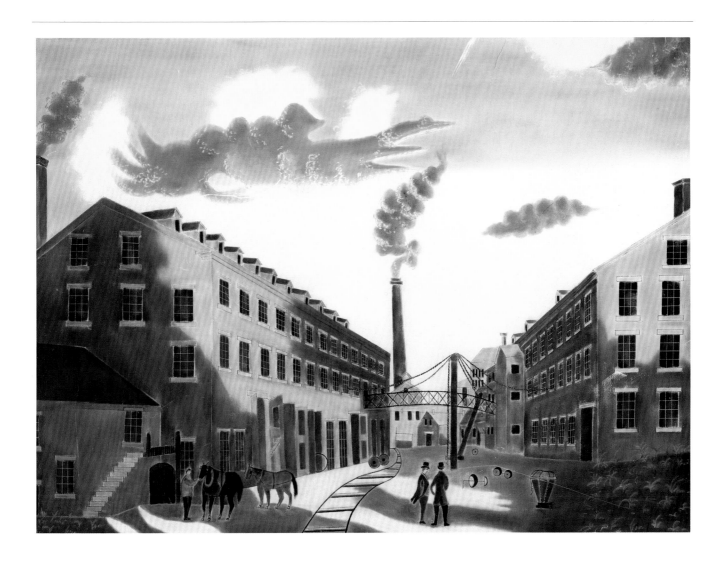

V.

DOCUMENTATION
Artist unknown
View of the Amoskeag Millyard, c. 1840
pastel on paper, 18 x 25
Collections of the Manchester Historic Association

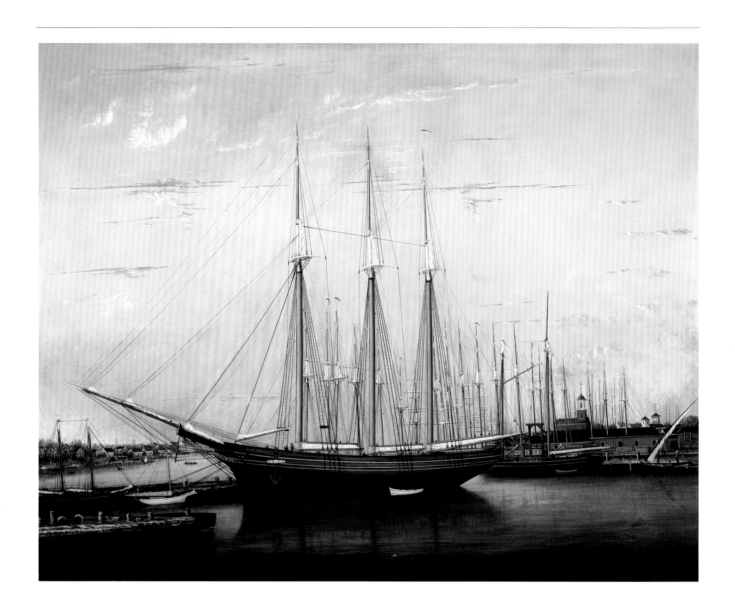

VI.
DOCUMENTATION
Thomas P. Moses (dates unknown)
Schooner, **Charles Carroll,** 1875
oil on canvas, 42½ x 54
Private Collection

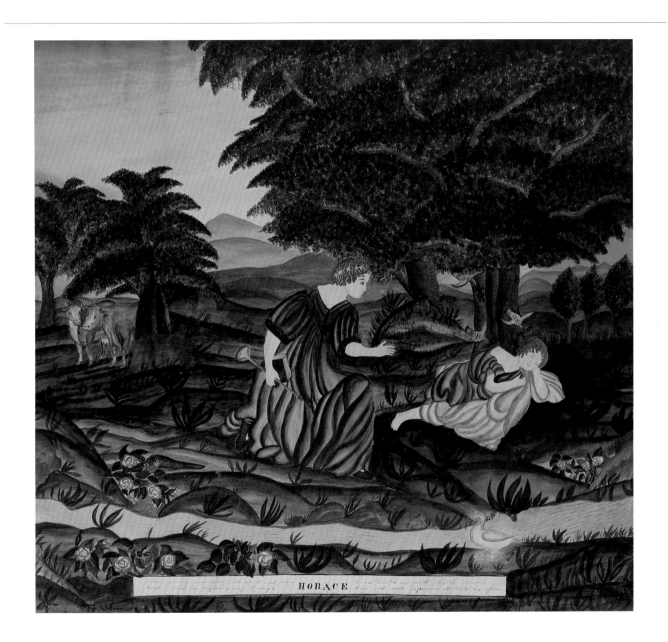

VII.
SELF-SATISFACTION
Maria M. Emes (1808–unknown)
A Verse from Horace, c. 1830
watercolor on paper, 20 x 22
Horatio Colony House Museum, Keene, New Hampshire

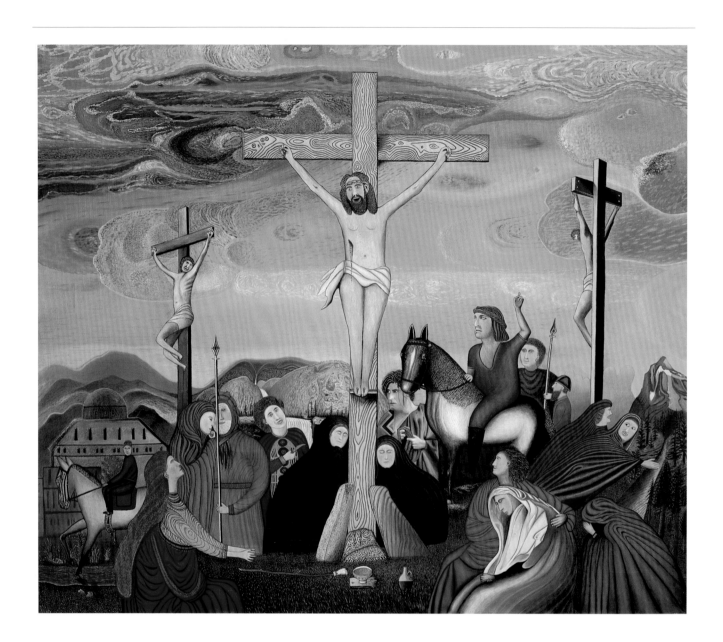

VIII.
SELF-SATISFACTION
Frank Baldwin (dates unknown)
The Crucifixion, c. 1925
oil on canvas, 40 x 48
Collection of David Bradstreet Wiggins

Decoration

By 1825, commerce was well established in New Hampshire. Portsmouth was a flourishing seaport, and Manchester (or Derryfield as it was known then) was already the site of the mills whose owners would soon merge their properties to form one of the largest manufacturing companies in America. Fortunes were made, and many entrepreneurs found themselves with the means to build, if not a mansion, at least a very substantial house. When built, it was filled with imported china, silver, and glass, while furniture and fabrics were acquired locally.

Many owners went still further to decorate their houses. In a booklet, *Country Art in New England 1790–1840*, originally published by Old Sturbridge Village in 1960, Nina Fletcher Little wrote:

> The use of paint, both for utility and decoration, played a very important part in New England village life during the first half of the nineteenth century. In isolated farm houses, remote from town or city, paint brought color, warmth, and interest to otherwise bare interiors. By means of his almost magic brush, a clever craftsman could produce effects that the rural family could not hope to achieve in any other way. Pine floors were decorated in imitation of woven carpets, wood paneling was simulated on plain plaster walls, best parlors bloomed with stenciled flowers. . . .

Fireplaces were a necessity and so was a parlor, the room in which all social activity took place. In order to emphasize the importance of the space, an artist was often brought in to create a painting on the overmantel, the paneled wall that covered the chimney. Following English custom, the image was usually a landscape, which provided the illusion of distant space. Since the purpose of the painting was only decorative, no attention was given to replicating a real scene. Despite similarities to various sites in New England, the scene painted for the overmantel of the Gardiner Gilman House in Exeter is a fantasy (figure 40).

A yearning for decoration, and the high cost of wallpaper, opened another opportunity for the artist—the wall mural. Nothing is known about the history of Archibald Macpheadris, but around 1700 he arrived in Portsmouth, and by 1716 had built an imposing house of brick, now known as the Warner House. For the walls of the stairwell, he commissioned a mural (figures 39 A–D), which is remarkable for its scale and boldness of execution. The artist and the subject matter are unknown, but two life-sized portraits adjacent to the landing window are copied from English prints. They are two of five Indians who traveled to London in 1710, where they were received with great enthusiasm. Their portraits were painted and copied as engravings for wider distribution to an eager audience.

The most prolific practitioner of mural painting in New Hampshire was Rufus Porter, a man gifted with tremendous imagination and energy, whose inventions and ideas were as extensive as his travels. In 1825, in Concord, he published *A Select Collection of Valuable and Curious Arts and Interesting Experiments,* which, among instructions for various kinds of household improvements, described "Landscape Painting on Walls of Rooms." He adopted the use of stencils and simplified the content of his images. In *Rufus Porter Rediscovered*

(Clarkson N. Potter, New York, 1980), his biographer, Jean Lipman, quotes Porter's own words to describe the elements of his pictures:

> As a general rule, a water scene—a view of the ocean or a lake—should occupy some part of the walls. . . . Other parts, especially over a fireplace, will require more elevated scenes, high swells of land, with villages or prominent and elegant buildings. . . . Small spaces . . . may be generally occupied by trees and shrubbery rising from the foreground, and without much regard to the distance.

Porter's murals are found mainly in southern New Hampshire and in the upper Connecticut River Valley.

While Porter benefited from the patronage of prosperous rural merchants and land owners, a few artists were being supported by the maritime trade. Ships were built on the banks of the Piscataqua River, in and near Portsmouth, and the government operated a naval shipyard in nearby Kittery, Maine. For a brief period, a few carvers were able to run shops which supplied figureheads, stern boards, and other pieces of woodwork for the local shipyards. The figurehead, another form of European origin, was designed to complement the bow of a ship. The name given to the vessel usually determined the character of the figurehead, which might become a symbolic figure, a national hero, a portrait of the owner, or a character from mythology, legend, or literature. Woodbury Gerrish probably turned to some printed source for ideas before carving the figure of a Spanish nobleman for the Portsmouth-owned-and-built ship *Grandee* (figure 51). The American eagle was favored by John Bellamy, who lived and worked in Kittery, Maine. But during the winter of 1859, he set up shop on Daniels Street in Portsmouth and carved the head of a lion to fit on the end of a cat's head, the beam that carried the ship's anchor chain (figure 52). Carvers also worked on the vessels of inland waters. Steamboats plied the waters of Lake Winnipesaukee, one of the largest inland bodies of water in America. In 1849, the Winnipesaukee Steamboat Company built the *Lady of the Lake*, and an unknown artist fashioned the female figure that graced the pilot house until 1893 when the vessel was retired and sunk (figure 50).

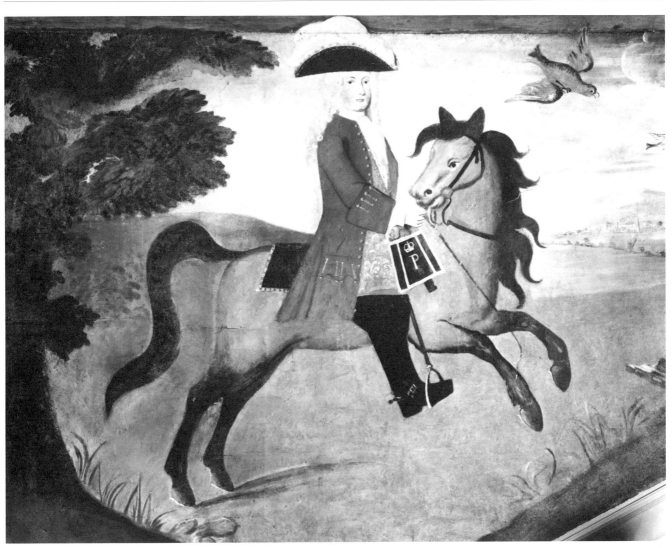

A.

39 A–D.
Artist unknown
Wall Mural, c. 1710
oil on plaster, 40 running feet
Warner House Association, Portsmouth, New Hampshire

B.

C.

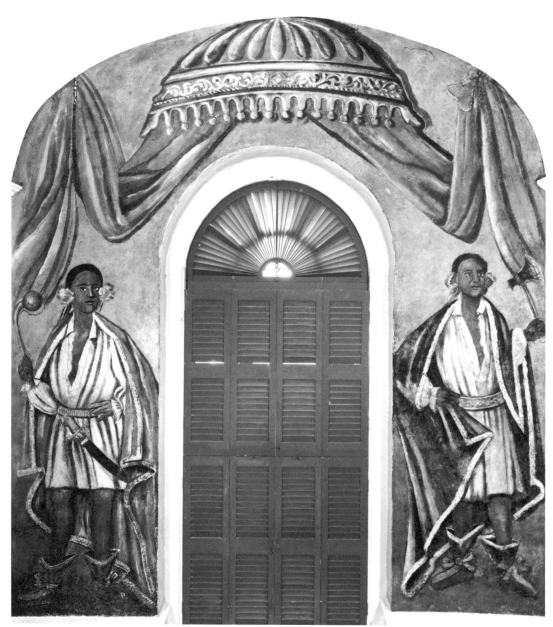

D.

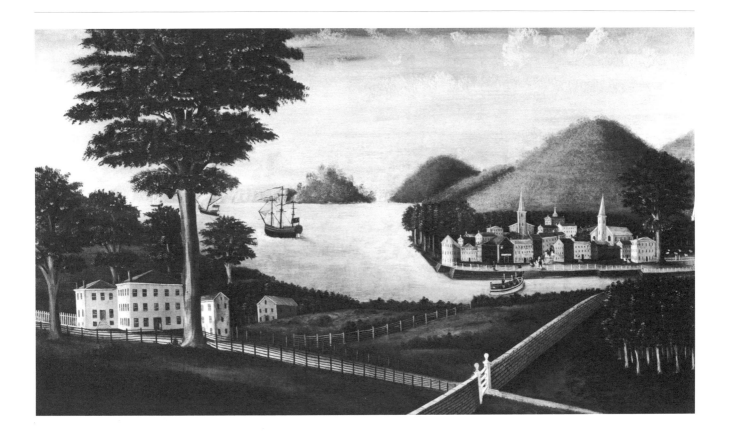

40.
Artist unknown
Overmantel from the Gardiner Gilman House, Exeter, New Hampshire, c. 1800
oil on wood panel, 28 x 48
Amon Carter Museum, Fort Worth, Texas

52

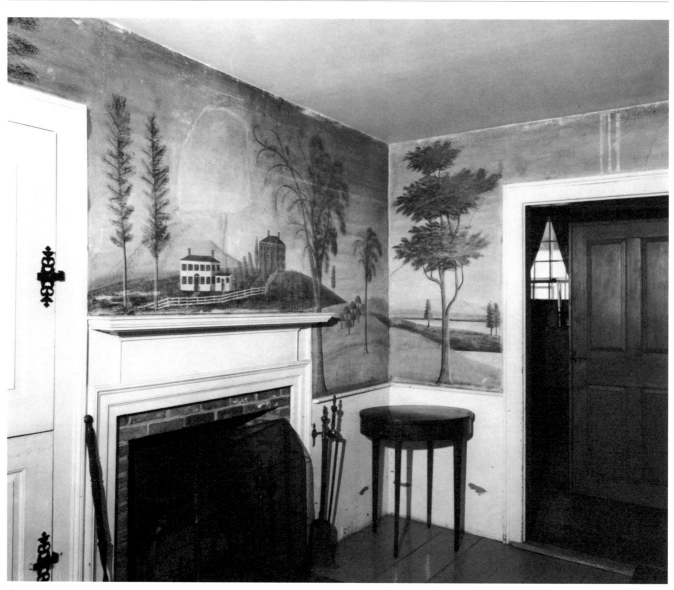

A.

41 A and **B.**
Rufus Porter (1792–1884)
Wall Mural, c. 1825
glue-medium paint on plaster, 62 x 287
The Cobb House; courtesy of Mr. and Mrs. Charles Cobb

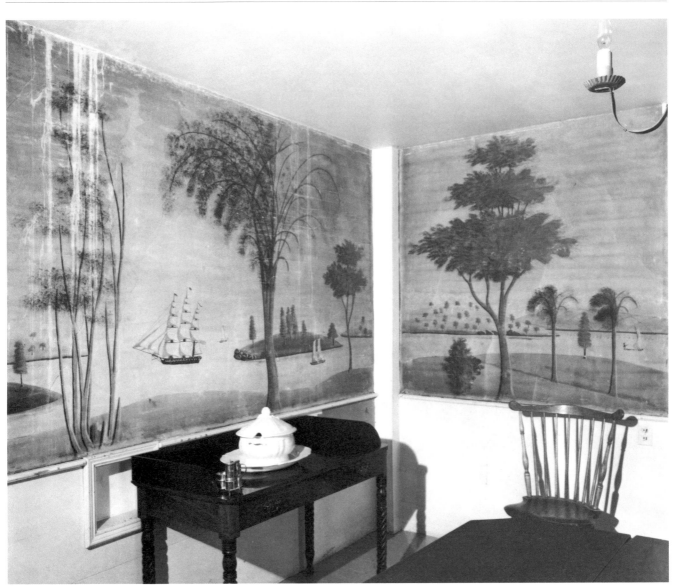

B.

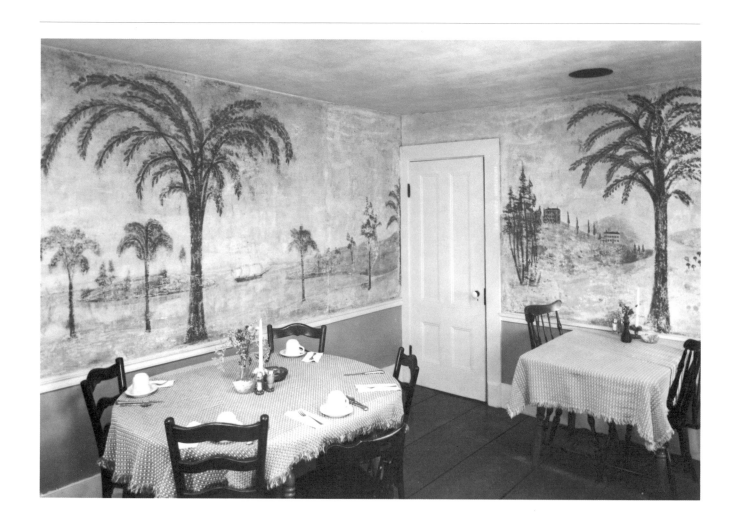

42.
Rufus Porter (1792–1884)
Wall Mural, c. 1825
glue-medium paint on plaster, 65 x 248
The Birchwood Inn; courtesy of Bill and Judy Wolfe

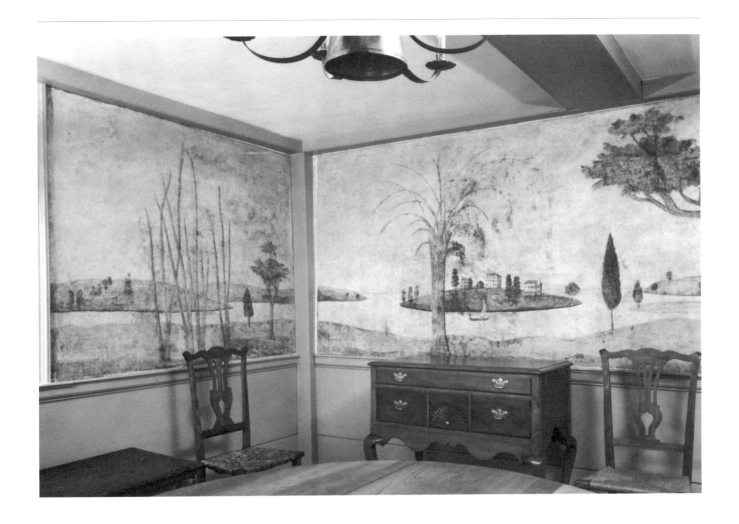

43.
Rufus Porter (1792–1884)
Wall Mural, c. 1825
glue-medium paint on plaster, 52 x 166
Private Collection

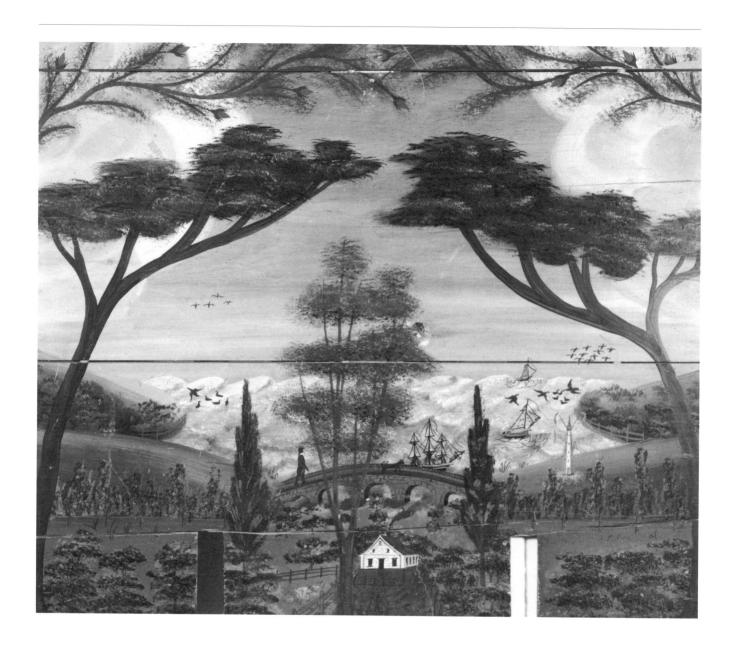

44.
Rufus Porter (1792–1884)
Fireboard from the James T. Garvin House, Greenfield, New Hampshire, c. 1825
oil on wood panel, 30½ x 36½
Collection of Mr. and Mrs. Samuel Shaer

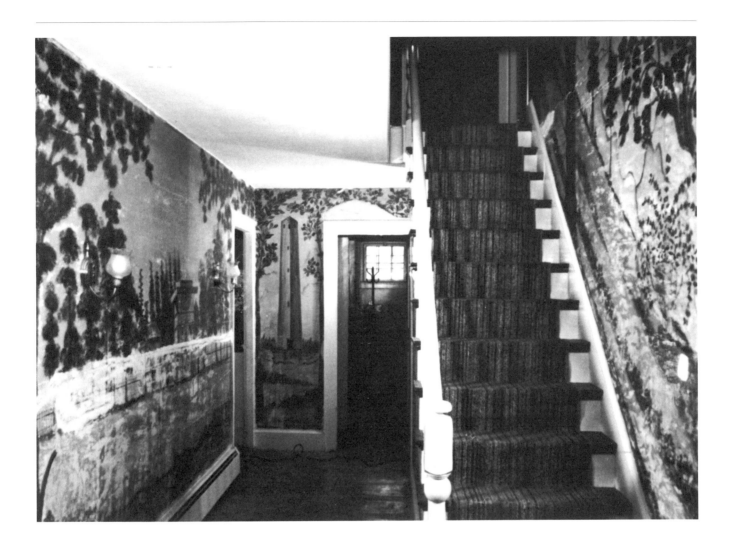

45.
John Avery (dates unknown)
Wall Mural, c. 1840
paint on plaster, 93 x 204
Photograph courtesy of David Ottinger

86

MENSURATION, of.
Problem XV.

To take the distance of any place, inaccessible, and so obscured as not to be seen from the given station. — RULE. Place two staves at C & D & two at E & F, so that ADC & AFE stand in like manner to A, then measure the angles CBE & DBE, & the sides CB, CD, DB, BF, EF, EB, which will be sufficient.

HEIGHTS, & DISTANCES.
Problem, 16,

To measure the distance between any two places inaccessible to each & — RULE. Chose a station where the two places are accessible & visible; as C. measure the distance between each of the objects A, B, & the station, & continue AC, BC 'till CD be equal CA, & CE to BC, then measure ED which is equal AB.

46.
Samuel W. Dow (dates unknown)
Mathematics Copybook, 1820
ink and watercolor on paper, 8 x 6½
Phillips Exeter Academy Library

From the top of a castle 156 yards above the level with the sea, the angle of depression of a ship at a distance was 35°40'. Reqd. the distance of the ship from the top of the castle?

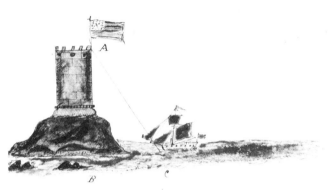

There are three towns A,B,C: at the town A, the town B & C make an angle of 90°12'; at B, the towns A & C make an angle of 38°30'; and the distance between A & B, is 2¾ miles. Required the distance between A & C and C and B?

As radius	10.
AB. 156	9.19312
Sec. ∠ a. 35°40'	10.0806
	12.27118
AC. 186.716	2.27118

As Sine ∠C 111°18'	9.930
AB. 2¾	0.439
Sine ∠B 38°30'	9.79415
	0.23346
AC. 2.34	0.30109

As Sine ∠C 111°	9.9340
AB. 2¾	0.43925
Sine ∠A 90°12'	9.99819
	9.97757
BC. 3¾ miles	0.60306

47.
John Wingate (dates unknown)
Mathematics and Navigation Copybook, 1794
ink and watercolor on paper, 8 x 6½
Phillips Exeter Academy Library; gift of D. W. Baker, '81

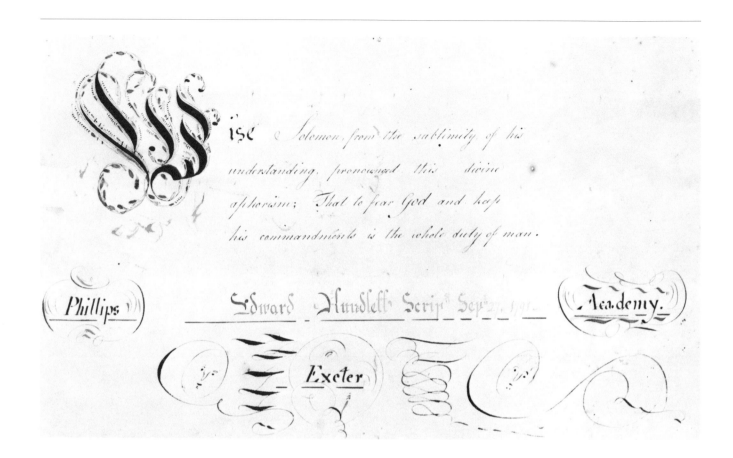

ise Solomon, from the sublimity of his understanding, pronounced this divine aphorism; That to fear God and keep his commandments is the whole duty of man.

Phillips

Edward Rundlett Scrip[t] Sep[t] 27. 1791

Academy.

Exeter

48.
Edward Rundlett (dates unknown)
Wise Solomon, 1791
ink and watercolor on paper, 7¼ x 12
Phillips Exeter Academy Library

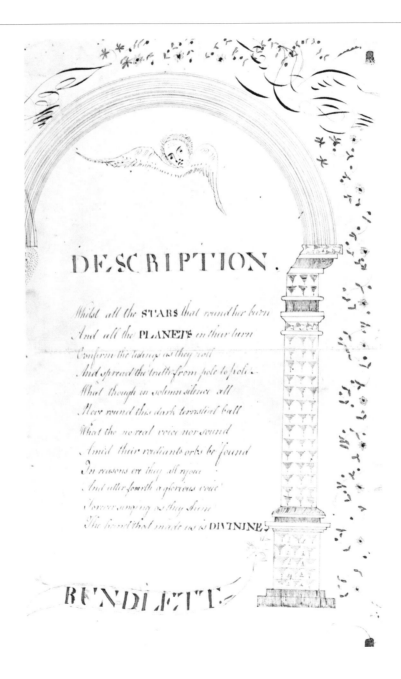

49.
Edward Rundlett (dates unknown)
Description, c. 1791
ink and watercolor on paper, 13 x 8
Phillips Exeter Academy Library

50.
Artist unknown
Lady of the Lake, c. 1849
painted and gilded pine, 60 x 26 x 29
New Hampshire Historical Society

51.
Woodbury Gerrish (dates unknown)
Figurehead of the Ship **Grandee,** 1873
painted wood, 96 x 40 x 48
Peabody Museum of Salem

52.
John H. Bellamy (1836–1914)
Decoration for a Cat's Head, 1859
wood, 13¼ x 14 x 4
Old Sturbridge Village

Communication

Some of the most obvious examples of art serving a function within the community are the signs that were created for use in the streets. For centuries, European tavern owners and merchants had used visual aids to announce the presence of their businesses and thus attract customers, many of whom were illiterate. Street signs used art for a single purpose, to arrest and hold attention. Color was bright; line, strong; and shapes, simple and bold.

The sign had to feature something unusual or special. The name of the owner was often incorporated, as it is in the Jones Tavern sign (figure 58), or the artist could draw upon the iconography of the new republic. Eagles, heroic figures, and patriotic symbols were popular, but domestic, classical, and natural subjects also competed for public attention.

Signs performed civic functions. Politics and patriotism required lavish use of national symbols. A banner (color plate III), thought to have been used in Vermont during the Van Buren and Harrison presidential campaign of 1840, includes references to independence, the twenty-six states of the Union, and the role of William Henry Harrison as a man of the soil, a pioneer, and a farmer. In a gesture of national fervor, the citizens of Portsmouth erected a flagpole and plaque with the words: "Erected July 4, 1824, in commemoration of July 4, 1776, that declared our emancipation from tyranny, and gave us the privileges of free men." In 1884, the plaque was replaced by a shield (figure 62), bearing the same message, until it, too, was replaced in recent years. Companies of volunteer firemen favored special regalia and uniforms, as well as romantic or local names for their apparatus, which were usually carved into elaborate signs

above the doors to the fire house (figures 66, 67). Special interest groups also used signs to carry their message, as the temperance sign from Sandwich attests (figure 68).

Signs often expressed the interests and associations of their owners. Both the Jones Tavern and the Cobleigh Tavern signs (figures 58, 59) provide evidence that the owners were members of the Order of Masons. Mr. Bartlett was apparently fascinated by the novelty of the new railroads, which were never important in Portsmouth, his place of business (figure 61). In order to participate in the celebration of Manchester's Semi-Centennial, George W. Pettigrew made a sign for the event and displayed it on his property (figure 69). From 1939 to 1942, Red Rolfe owned a gas station in Penacook. Since he was also something of a celebrity at the time, playing third base for the victorious New York Yankees during six World Series, the sign for his business eulogized him and not the product (figure 71).

Until the invention of the typewriter, writing by hand, or calligraphy, was a much needed skill for success in business or social relationships. It was taught in the schools, and teachers often gave models of their own penmanship to good students, usually in the form of achievement certificates (figures 56, 57). In the latter half of the nineteenth century, a number of instruction manuals were published, each advocating a system of self-instruction. Those who could write well, and produce rather elaborate linear designs and illustrations with the pen, established themselves in business to teach penmanship and produce goods such as business and visiting cards. Elaborate specimens of their work served as advertisements for their services (figures 64, 65).

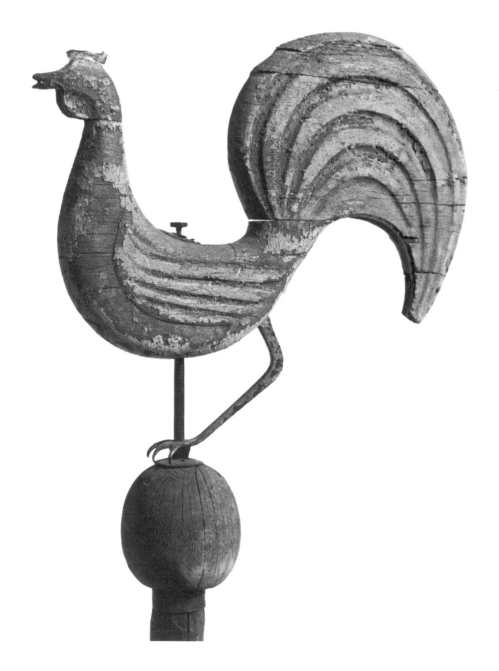

53.
Artist unknown
Weathercock, 1799
painted wood and iron, 24 x 28 x 3
Boscawen Public Library; courtesy of the Boscawen Historical Society

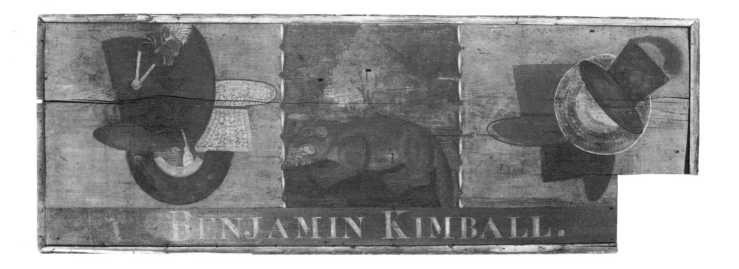

54.
Artist unknown
Sign from the Shop of Benjamin Kimball, c. 1792
oil on wood panel, 31¼ x 90 x 3
New Hampshire Historical Society

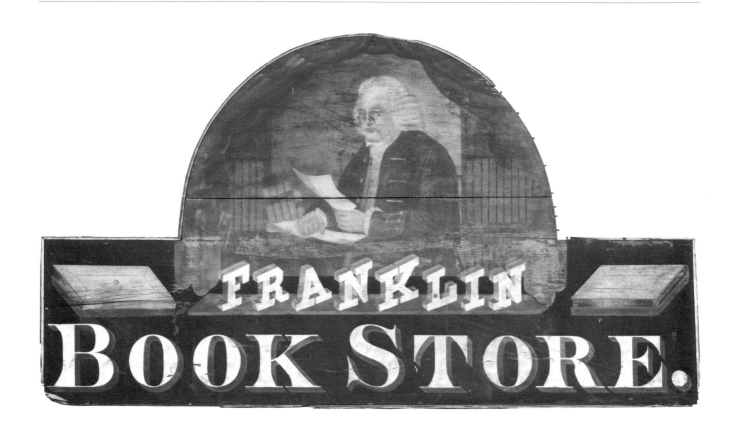

55.
William Low (1779–1847)
Sign from Franklin Bookstore, Concord, New Hampshire, c. 1810
oil and sand on wood panel, 48 x 72 x 2
New Hampshire Historical Society

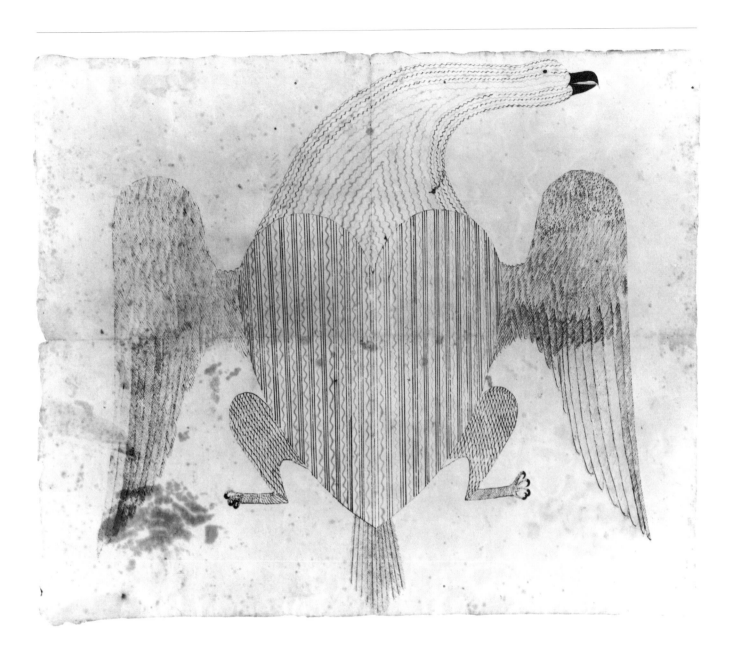

56.
Benjamin Proctor (1786–1848)
Certificate of Merit, 1817
ink on paper, 13¼ x 16
New Hampshire Historical Society; gift of Alexis C. Proctor

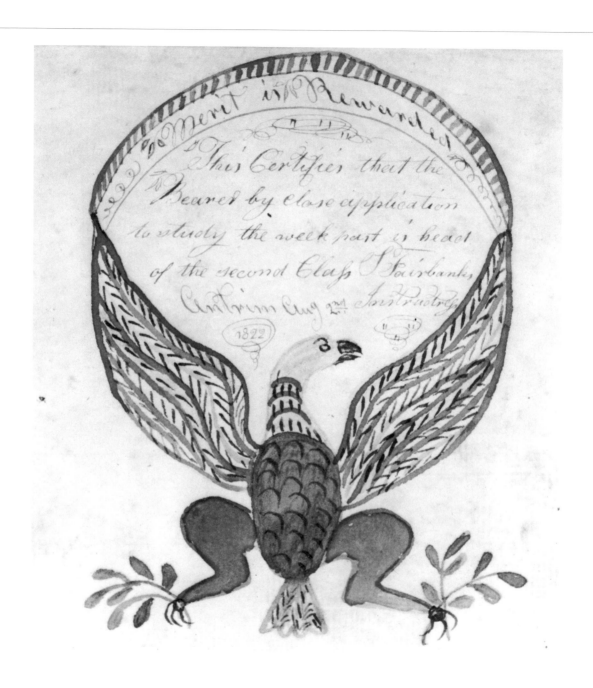

57.
Sarah Fairbanks (dates unknown)
Certificate of Merit, 1822
ink and watercolor on paper, 4¼ x 4½
New Hampshire Historical Society

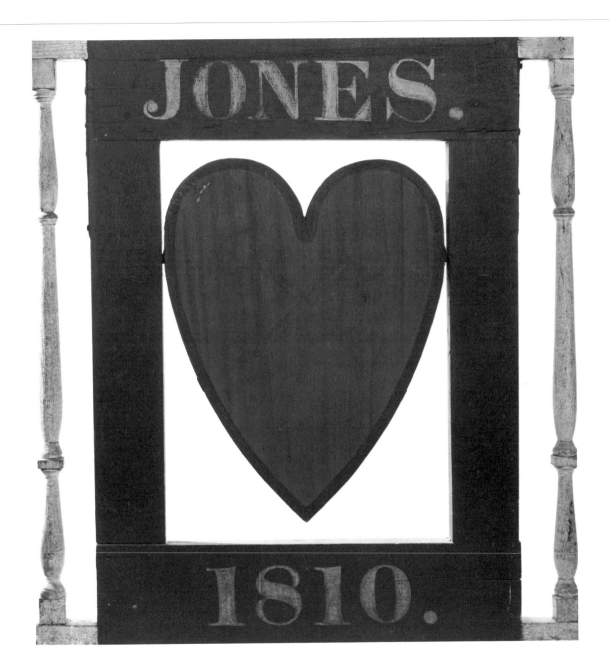

58.
Artist unknown
Jones Tavern Sign, 1810
oil on wood panel, 34 x 30¾ x 2
The Currier Gallery of Art, Manchester, New Hampshire;
bequest of Miss Elizabeth Jones

59.
Artist unknown
Cobleigh Tavern Sign, 1824
painted wood, 47 x 36
Sugar Hill Historical Museum, Sugar Hill, New Hampshire

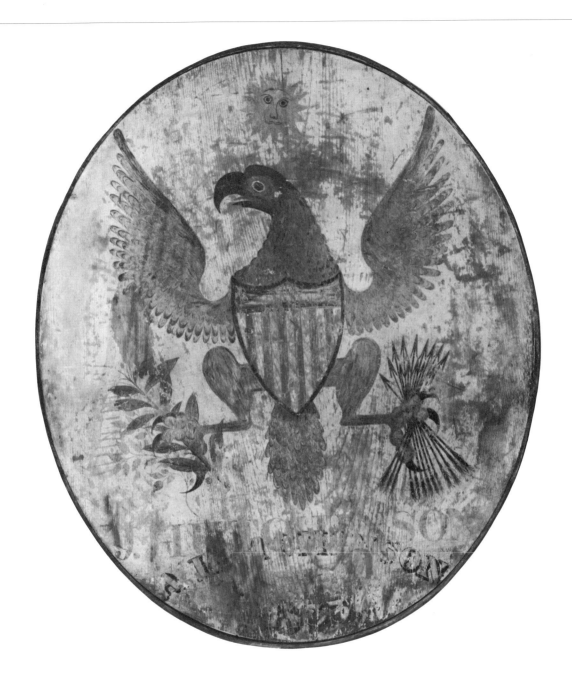

60.
Artist unknown
Tavern Sign, 1873
painted wood, 43½ x 37½ x 1½
The Milford Historical Society; gift of Edward D. Searles

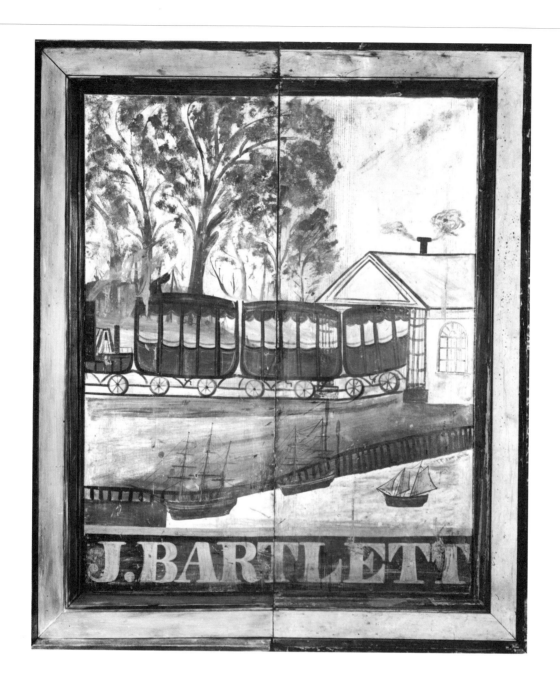

61.
Artist unknown
Signboard for J. Bartlett's Hotel, Portsmouth, New Hampshire, c. 1835
oil on wood panel, 42½ x 35
Private Collection

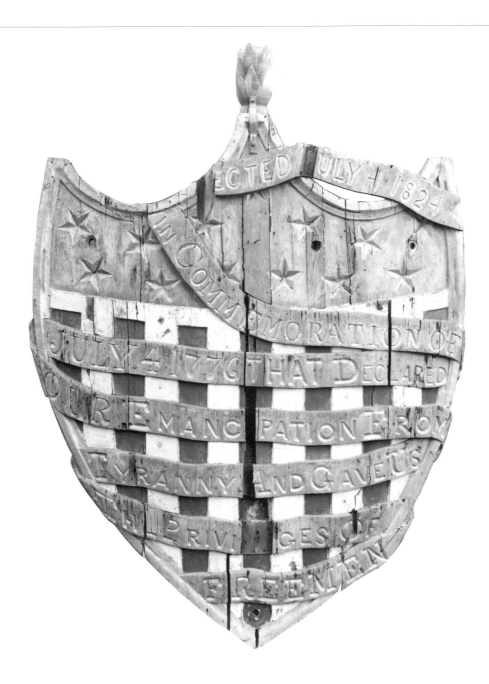

62.
Artist unknown
Patriotic Symbol, 1884
painted wood, 52 x 35 x 3
The Trustees of Prescott Park, Portsmouth, New Hampshire

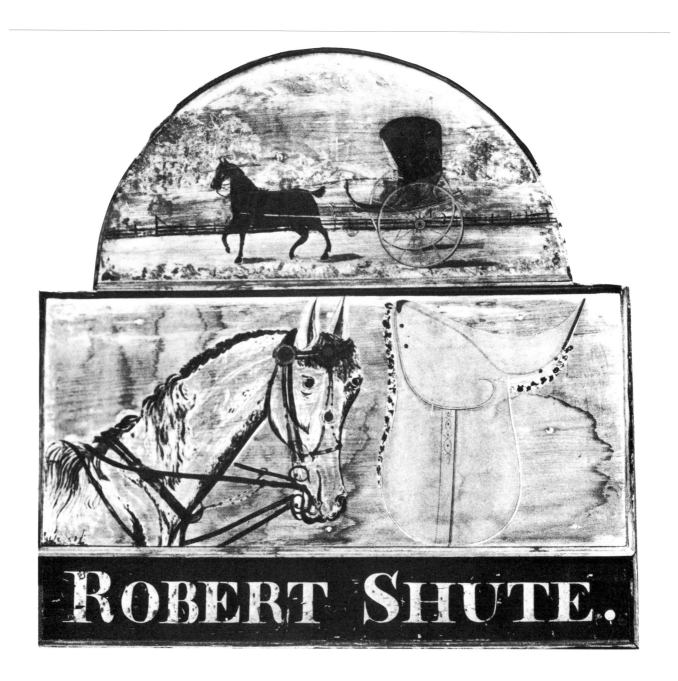

63.
Artist unknown
Sign for Shop of Robert Shute, Harness Maker, c. 1840
painted wood, 56 x 56½ x 2½
Heritage Plantation of Sandwich, Massachusetts

64.
James L. Chase (1854–1906)
Calligraphic Advertisement, c. 1875
ink on paper, 10 x 14
New Hampshire Historical Society

65.
Ivarr Gilbert (dates unknown)
The Lord's Prayer, c. 1880
ink on paper, 25½ x 22½
Collections of the Manchester Historic Association

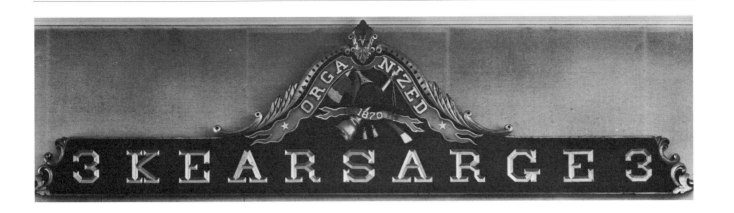

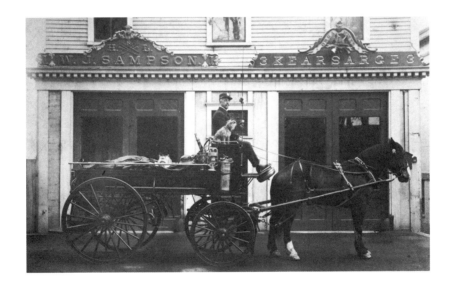

66. and **67.**
Artist unknown
Fire House Signs, "Kearsarge"** and **"W. J. Sampson," c. 1875
oil on wood, 42 x 168 x 9 and 39 x 174½ x 6
Addison Gallery of American Art, Phillips Academy, Andover, Massachusetts

Photograph of "W. J. Sampson" and "Kearsarge" signs on fire house,
Portsmouth, New Hamsphire, c. 1875, photographer unknown

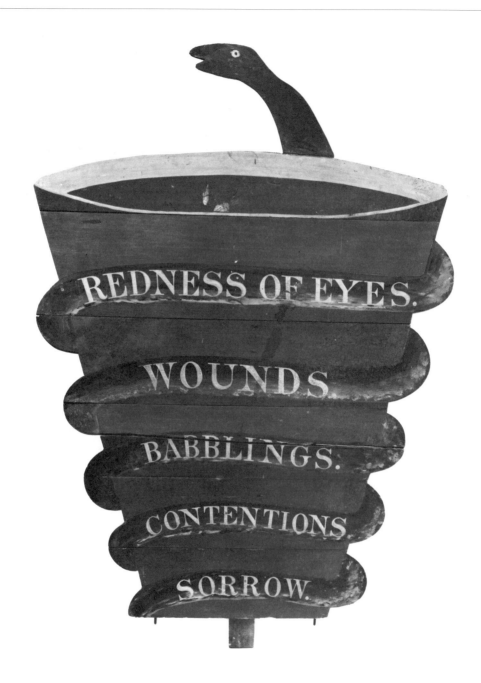

68.
Artist unknown
Temperance Sign, c. 1890
oil on wood, 35 x 25 x ½
Sandwich (New Hampshire) Historical Society

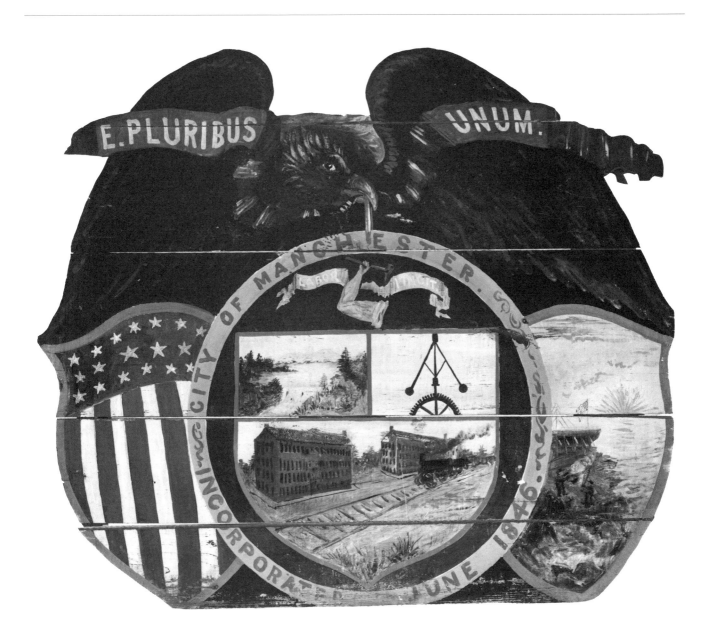

69.
George W. Pettigrew (dates unknown)
Sign for the Manchester Semi-Centennial, 1896
oil on wood, 72 x 72 x 2
Collections of the Manchester Historic Association

70.
Herbert Dunbar and William McLeod (dates unknown)
Sign for Lewis G. Gilman's Apothecary Shop, c. 1900
oil on wood, 71½ x 33 x 2
Collections of the Manchester Historic Association; gift of Lewis B. Gilman, Jr.

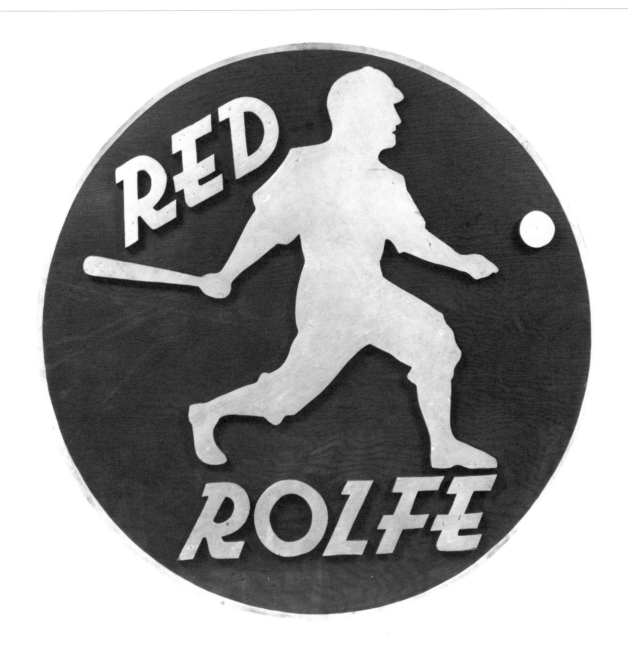

71.
Artist unknown
Red Rolfe, 1939
painted wood, 36 x 1½
Phyllis Randall Collection

Documentation

By the mid–nineteenth century, life in New Hampshire had been greatly affected by the growth of industry and the coming of the railroad. Manchester and Nashua, situated on the banks of the Merrimack River, became factory towns with activity centered on the huge brick buildings that housed machines for the manufacture of goods, mainly textiles. Labor to run the machines was imported or drafted from the farms. Merchants who served these workers' needs prospered. As better transportation made the distribution of goods easier, there was less necessity to make or grow everything that was essential for daily life. There were more schools, and they offered classes in skills such as calligraphy, drawing, and painting. More leisure time gave some the opportunity to indulge in pastimes unrelated to their livelihood, and many chose to make art.

Free to select their subject matter, amateurs who found portraiture too difficult could make landscapes or images recording some personal experience. Although started with a specific subject in mind, the result was apt to be more conceptual than realistic. The figure of the Marquis de Lafayette looms larger than life in the tavern of Joseph Warren Leavitt (color plate IV), where the famous ally had paused on his trip from Portsmouth to Concord. A limited agility with the pen did not prevent Alfred Abell from capturing the excitement of a bear hunt (figure 73).

Some images of the New Hampshire landscape were meticulously rendered, preserving precious details of time and place. S. W. Danforth was a faithful and capable witness for the town of Peterborough as the village emerged from the rural

landscape (figure 78). Sometimes these pictures ignore the laws of perspective, but they are always a compendium of information. *The Seat of Colonel George Boyd* (figure 72), perhaps the first landscape of a specific site painted in New Hampshire, is also one of the earliest images of Portsmouth, a colonial seaport. The Colonel probably took the picture back to England, where it was found, in order to prove to his peers that he had done well in the colonies. Florence Lee Wilson (figure 80) and Thomas P. Moses (color plate VI) had no such notions of grandeur, but their paintings of rural and maritime New Hampshire also furnish extensive information about the domestic and marine architecture of their time.

Sensitive to the natural beauty of the landscape in New Hampshire, many artists created a lasting record of the land. Whether by chance or by intent, they documented the industry and commerce that were changing southern New Hampshire from a natural paradise to an industrial stronghold. As George McConnell, and others, made paintings of the industrial complex built by the Amoskeag Manufacturing Company in Manchester (figures 76, 77), they were reacting to a change of great significance taking place around them. With pen, pencil, and brush, they recorded history in the making.

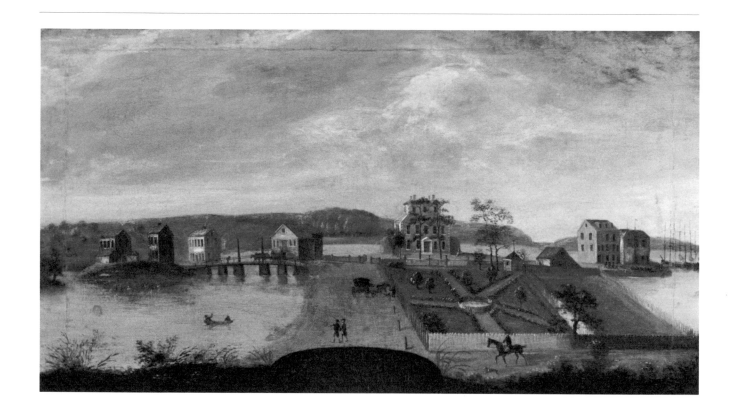

72.
Artist unknown
Seat of Colonel George Boyd, 1774
oil on canvas, 17 x 32
The Lamont Gallery, Phillips Exeter Academy, Exeter, New Hampshire;
gift of Thomas W. Lamont, Class of 1888

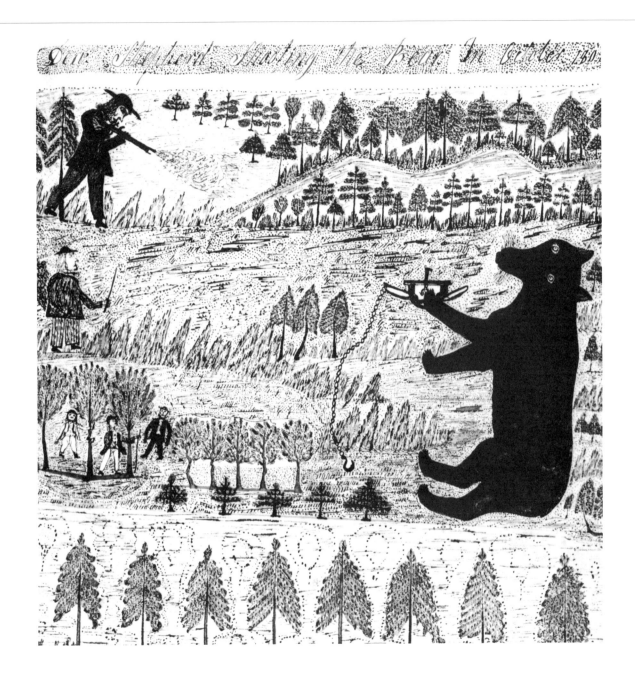

73.
Alfred Abell (dates unknown)
Dea Shepherd Shooting the Bear in October, 1808, c. 1837
ink and watercolor on paper, 6½ x 6¾
Private Collection

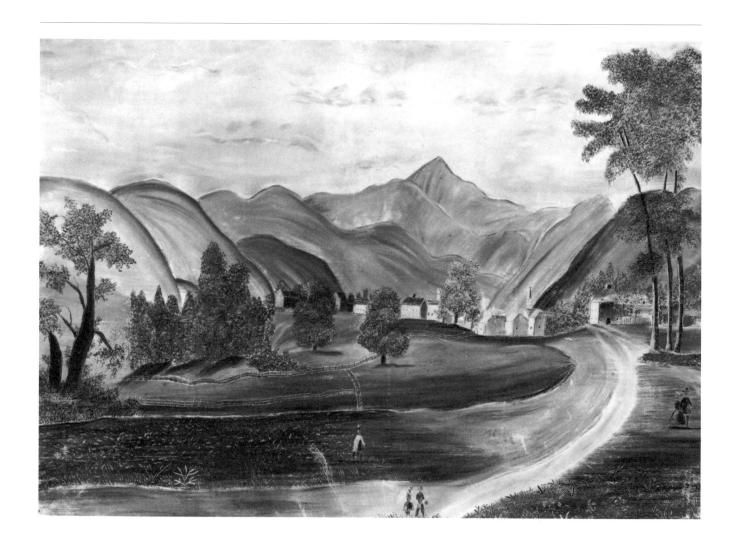

74.
Artist unknown
View of Mt. Washington Valley, c. 1840
charcoal on paper, 14½ x 21
Private Collection

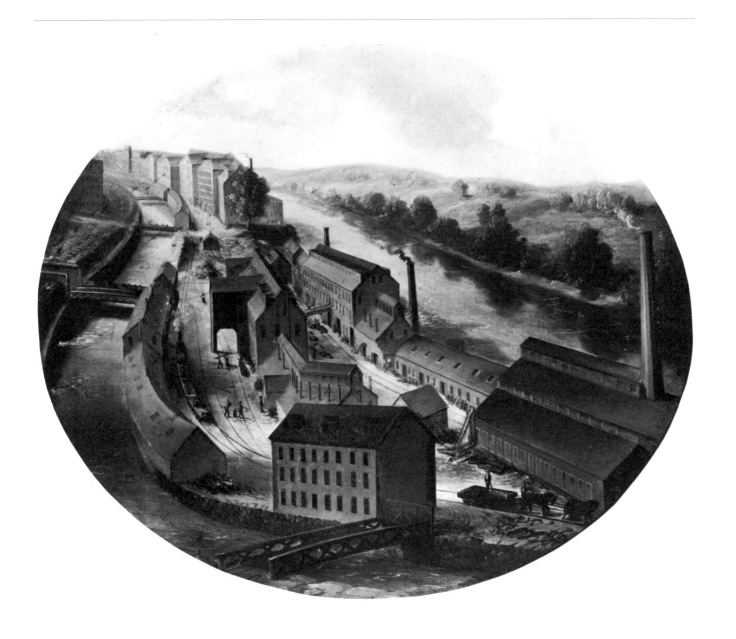

75.
Artist unknown
Amoskeag Millyard, c. 1850
oil on canvas, 17¾ x 21⅜
Collections of the Manchester Historic Association

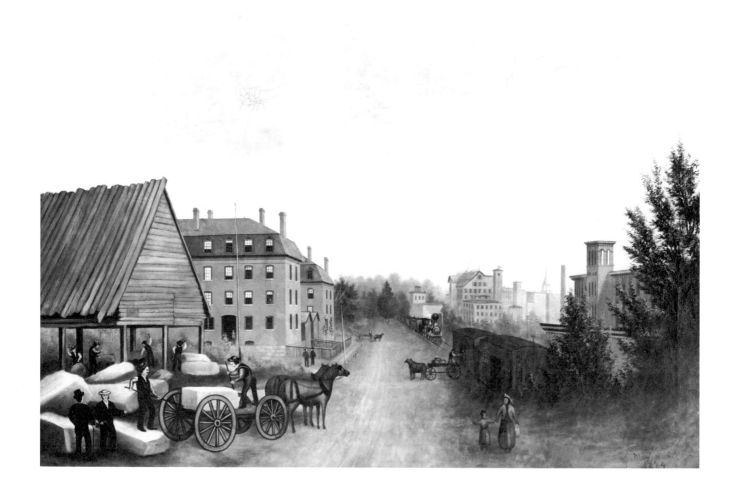

76.
George McConnell (dates unknown)
View of Manchester, 1874
oil on canvas, 29½ x 43
Collections of the Manchester Historic Association

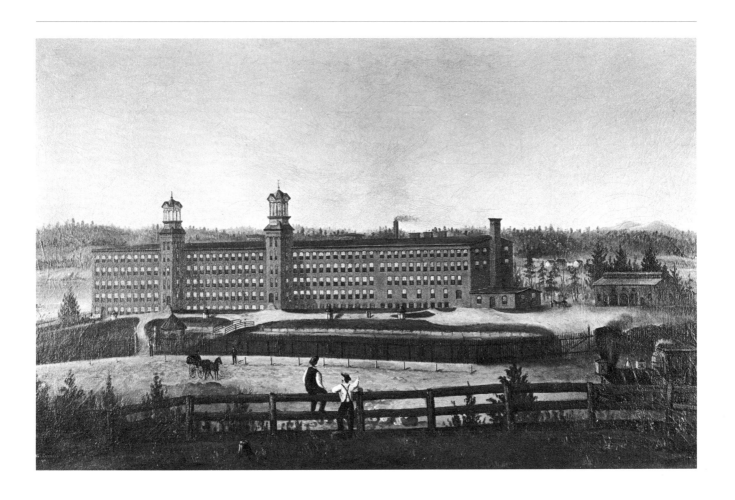

77.
George McConnell (dates unknown)
The China Mill, 1871
oil on canvas, 34 x 53¾
New York State Historical Association, Cooperstown

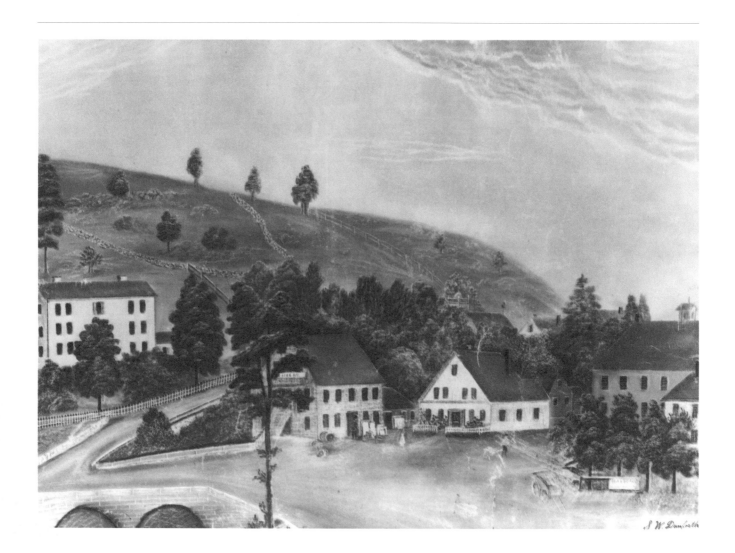

78.
S. W. Danforth (dates unknown)
View of Peterborough, c. 1856
charcoal on paper, 14½ x 20½
Peterborough Historical Society, Peterborough, New Hampshire

79.
Artist unknown
Manchester Poor Farm, c. 1880
gouache on paper, 21 x 27
Collections of the Manchester Historic Association

80.
Florence Lee Wilson (1877–1917)
Burnap Homestead, 1894
oil on board, 15½ x 24
Phyllis Randall Collection

PITTSFIELD, N.H.

81.
H. Sawyer (dates unknown)
The Osborne Farm, Pittsfield, New Hampshire, 1904
watercolor on paper, 16 x 21
Private Collection

Self-Satisfaction

Artists arrive at very personal solutions to the problems of making an object or an image, although their responses are conditioned by common associations, experience, and background. Artists draw upon a knowledge of life, and attempt to reconcile the real world and a visionary concept. Dorothy Graham was compelled to draw and paint imaginary buildings and landscapes and, occasionally, to reflect on the human condition by making a picture such as *The Doomed Ship* (figure 100). Frank Baldwin, a successful businessman in Pittsburgh, New Hampshire, turned to art and made his own interpretation of personal tragedy (color plate VIII) when, following some bad decisions, his business failed and his wife deserted him.

Regional and ethnic lore, religion, national and military history, real places and events, memories, and fantasies are all potential inspiration for a subject. Today, Stuart Williams watches the animals on the farm where he lives and then reconstructs their world as his own (figure 99). It may be a personal world or a personal vision of a common universe, but it is always a world remade to please a particular sensibility. In order to stand aside from the real world, Emily Eastman, Sally Hodgdon, Maria Emes, and Christopher Columbus Fellows invented fantasies which they made into images for their own pleasure. George Boyd of Seabrook made shoes for a living, but the birds of the seashore were his passion. The decoys he made were both useful and beautiful (figures 96, 97, 98).

Sometimes the urge to create follows a personal catastrophe, such as crippling illness or an accident. Sometimes making art fills a void brought on by unemployment or retirement. A number of the artists who emerged in the twentieth century were elderly and no longer forced to cope with the demands of making a living. Their images came from the mind's eye, a distillation of scenes and impressions received and retained throughout a lifetime. Ellie Gagnon never made a picture until her family was grown and she had stopped working as a nurse. Now, each painting she makes begins in her memory (figure 102). Her world is one of tranquility, New Hampshire as a Garden of Eden. Joseph Carreau also devoted a lifetime to family and work. Using cheap materials, he found a very personal way to make pictures of the landscape (figure 101).

The work of Joseph Carreau, Dorothy Graham, Ellie Gagnon, and Stuart Williams exemplifies the act of creation as an assertion of individuality combined with an intense desire to work and a private sense of self-worth. Sensitive and introspective, these artists confront life and art with a special commitment. At the most, their work is an obsession, an attempt to modify reality, and it is never less than a striving to seek the promise of a new experience.

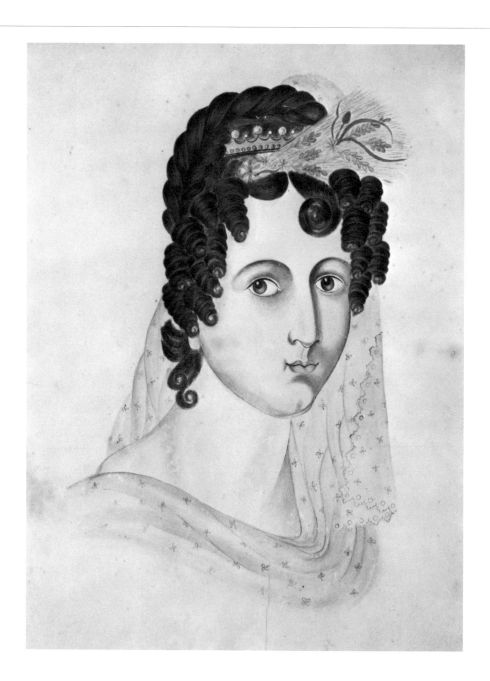

82.
Emily Eastman (active 1820–1840)
Lady's Coiffure with Flowers and Jewels, c. 1830
watercolor and graphite on paper, 17 x 13½
Museum of Fine Arts, Boston; M. and M. Karolik Collection

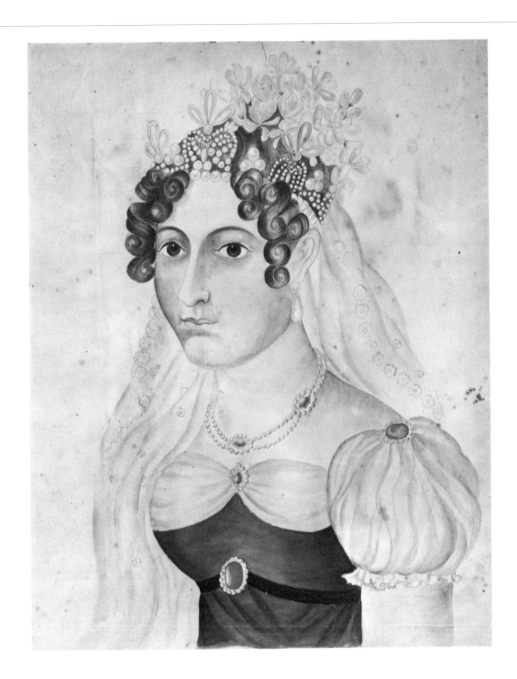

83.
Emily Eastman (active 1820–1840)
Lady's Coiffure with Spray of Wheat and Wild Flowers, c. 1830
watercolor and graphite on paper, 16⅛ x 12
Museum of Fine Arts, Boston; M. and M. Karolik Collection

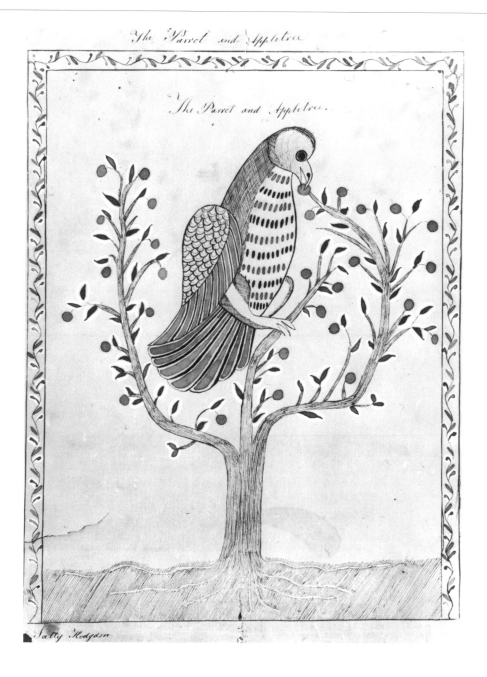

The Parrot and Appletree.

84.
Sally Hodgdon (1780–1855)
The Parrot and Appletree, c. 1810
ink and watercolor on paper, 14½ x 11¾
New Hampshire Historical Society

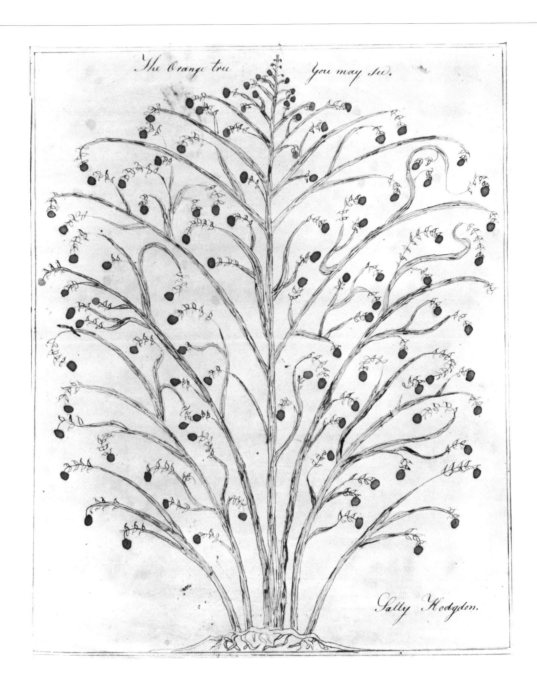

85.
Sally Hodgdon (1780–1855)
The Orange Tree You May See, c. 1810
ink and watercolor on paper, 14 x 11¾
New Hampshire Historical Society

86.
Sally Hodgdon (1780–1855)
Untitled, c. 1810
watercolor on paper, 7½ x 6¾
New Hampshire Historical Society

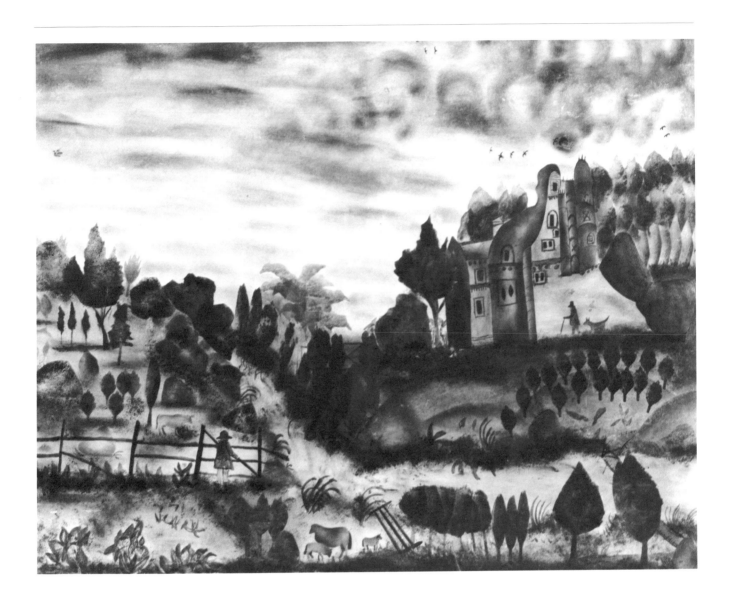

87.
Maria M. Emes (1808–unknown)
Romantic Landscape, c. 1830
watercolor on paper, 14¼ x 18
Horatio Colony House Museum, Keene, New Hampshire

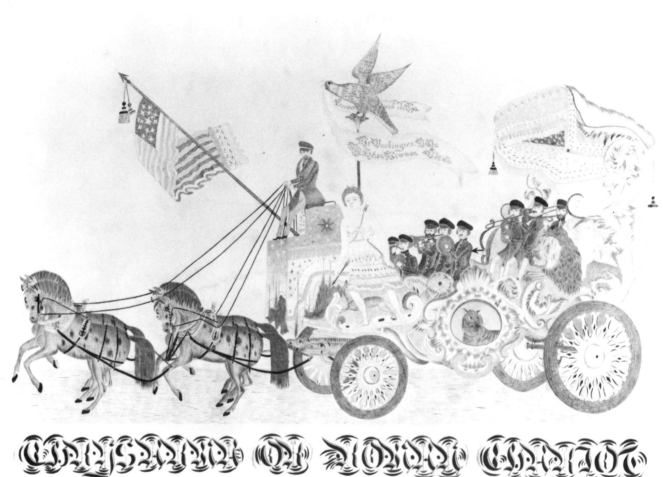

88.
Solon Newman (1832–1904)
Chrysarma, or Roman Chariot, 1854
ink on paper, 19 x 27½
New Hampshire Historical Society

89.
Mary Octavia Sparhawk (1830–1910)
Landscape, c. 1870
pastel on paper, 9½ x 9½
Walpole Historical Society

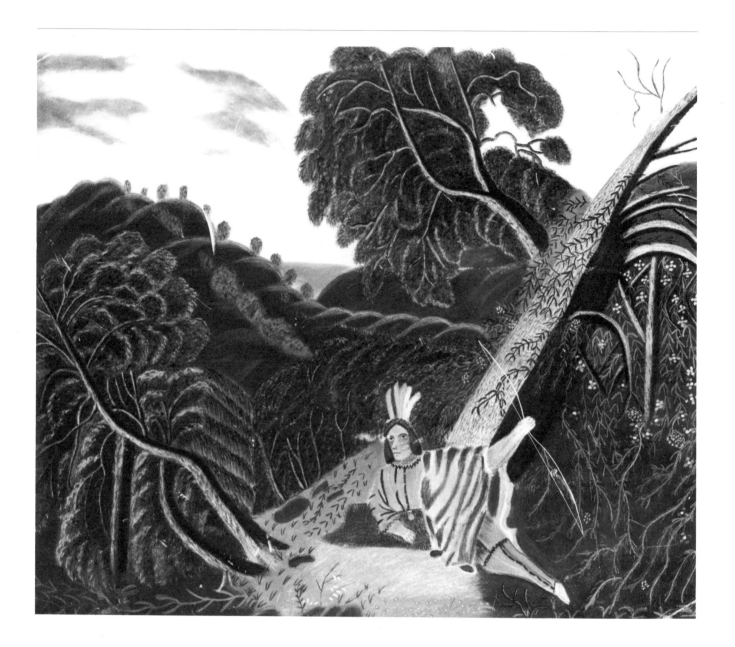

90.
Anna Elizabeth Lancaster Hobbs (dates unknown)
Indian Hunter with Bow, c. 1840
pastel on sanded paper, 17¼ x 20¾
Hood Museum of Art, Dartmouth College, Hanover, New Hampshire;
purchased through the Julia L. Whittier Fund

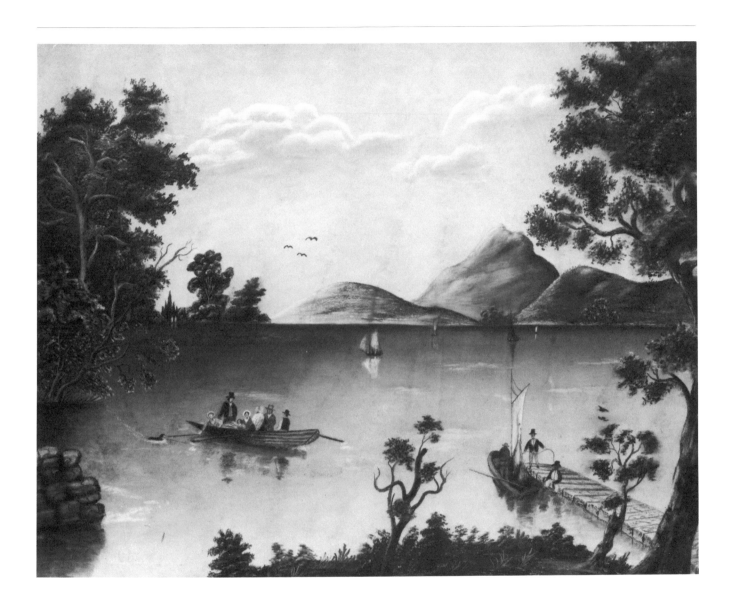

91.
Christopher Columbus Fellows (1820–1888)
The Pleasure Excursion, c. 1880
pastel on paper, 17½ x 22¼
Sandwich (New Hampshire) Historical Society

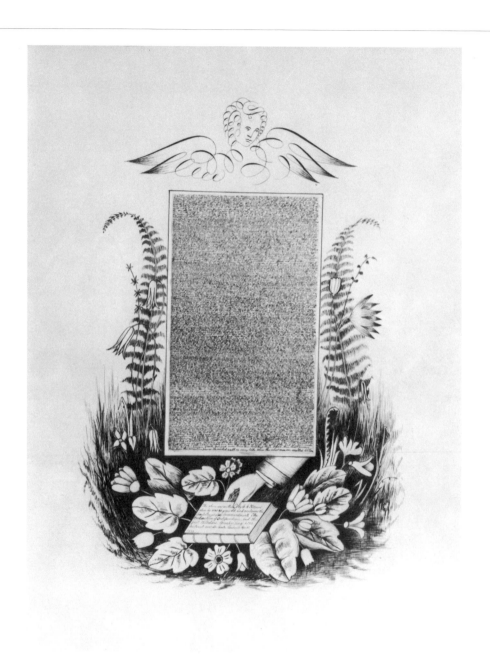

92.
Christopher Columbus Fellows (1820–1888)
Calligraphy, 1880
ink on paper, 12¼ x 9½
Sandwich (New Hampshire) Historical Society

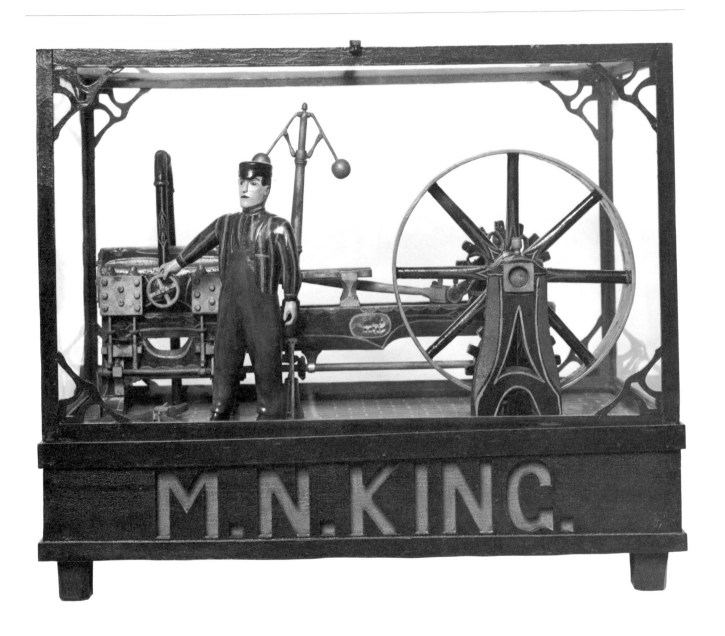

93.
Marion N. King (1845–unknown)
Man and Machine, 1863
painted wood and glass, 20 x 23½ x 13
Nashua Historical Society; gift of Marion and Francis King

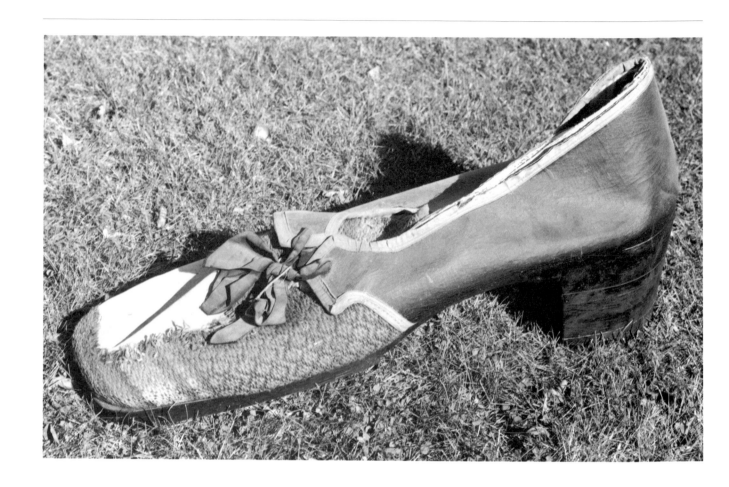

94.
Artist unknown
Matrimonial Shoe, 1884
mixed media, 12½ x 26 x 8
Fitts Museum, Candia

95.
Artist unknown
Whirligig, c. 1875
painted wood, 29 x 10 x 5
Private Collection (photograph courtesy of David A. Schorsch, Inc.)

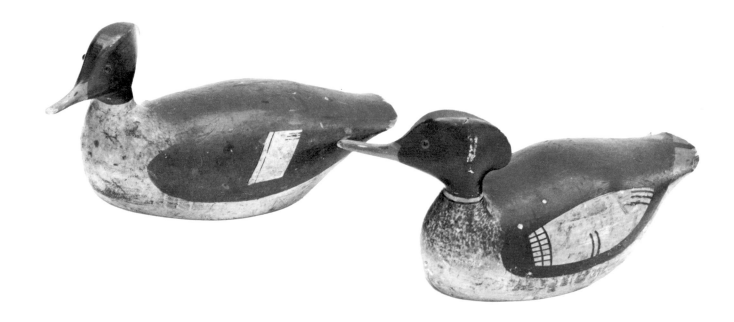

96.
George Boyd (1873–1941)
Pair of Merganser Duck Decoys, c. 1925
painted wood, 7¼ x 17½ x 6½ and 7½ x 16½ x 6
Private Collection

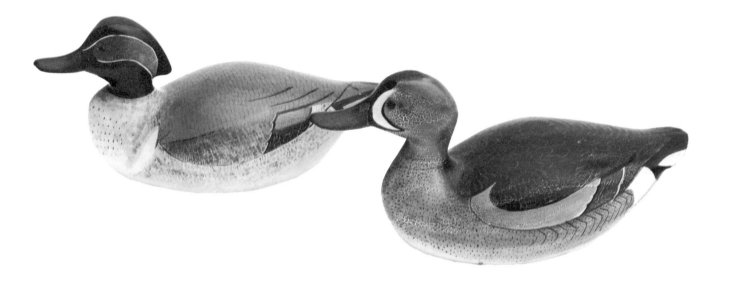

97.
George Boyd (1873–1941)
Pair of Teal Duck Decoys, c. 1925
painted wood, 5¼ x 11½ x 5¼ and 6 x 12½ x 5
Private Collection

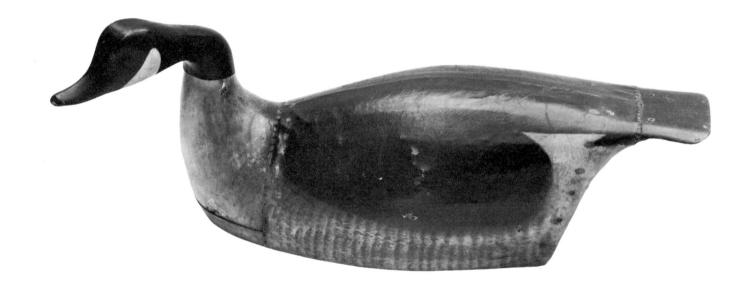

98.
George Boyd (1873–1941)
Canada Goose Decoy, c. 1925
canvas, metal, wood, and paint, 10¼ x 26½ x 8½
Private Collection

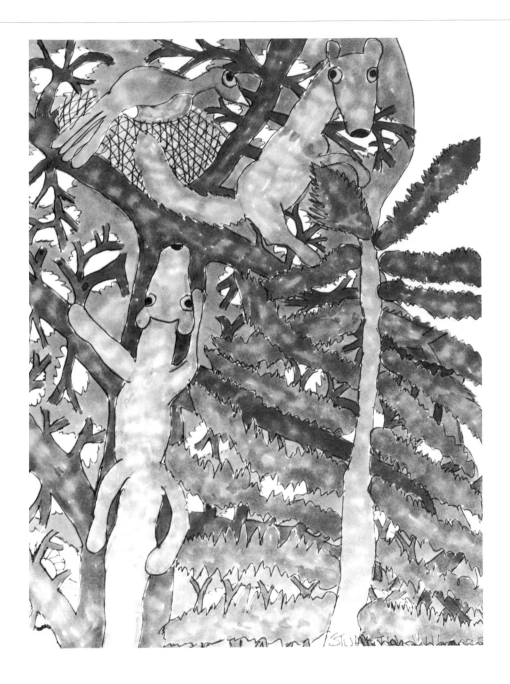

99.
Stuart Williams (b. 1950)
Squirrels and Bird, 1986
ink on paper, 14 x 11
Private Collection

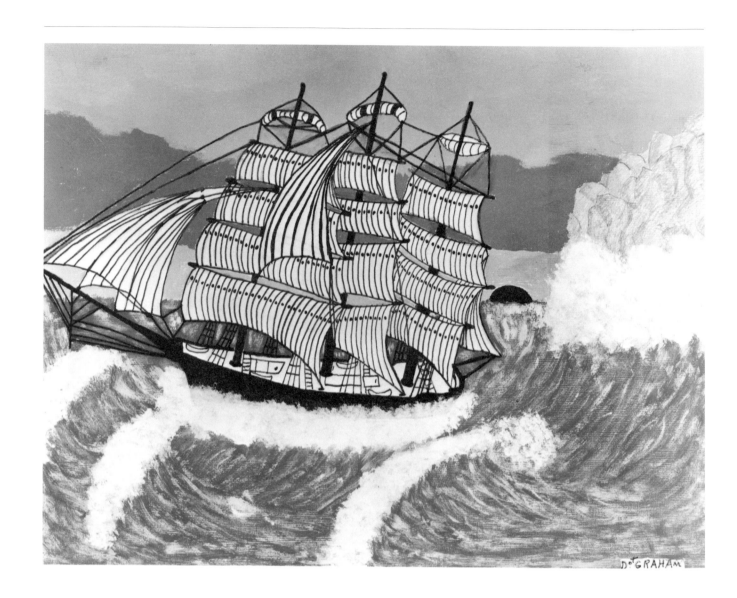

100.
Dorothy Graham (1916–1987)
The Doomed Ship, 1985
ink on paper, 12 x 16
Private Collection

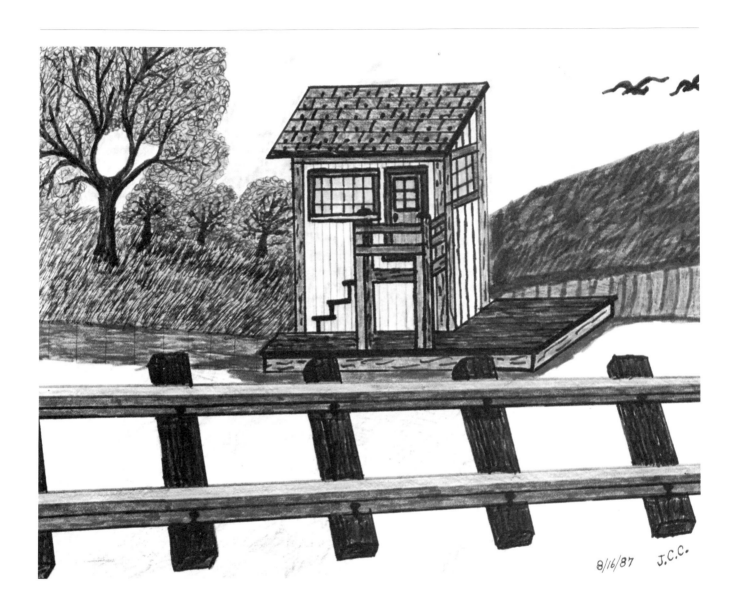

101.
Joseph C. Carreau (b. 1917)
The Switch House, 1987
ink on paper, 8½ x 11
Private Collection

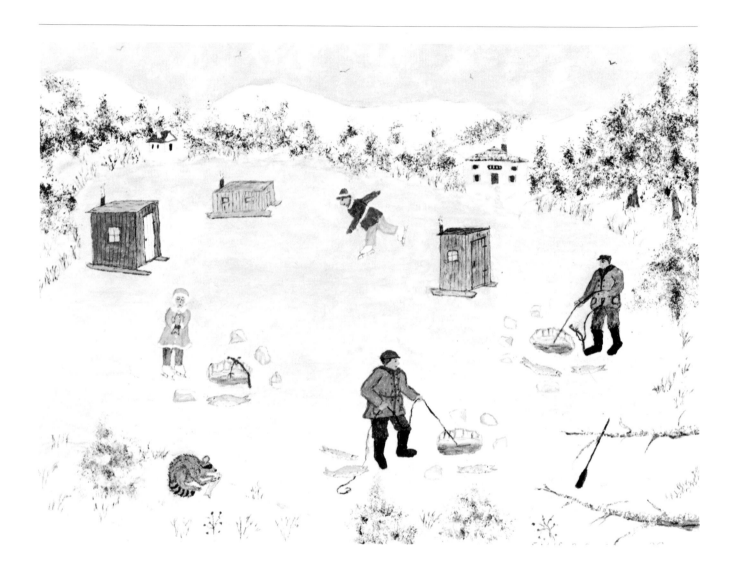

102.
Ellie Gagnon (b. 1906)
Ice Fishing, 1988
oil on board, 14 x 18
Private Collection

Suggested Readings

BOOKS

Ames, Kenneth L. *Beyond Necessity: Art in the Folk Tradition*. Winterthur, Del.: Henry Francis du Pont Winterthur Museum, 1977.

Bowles, Ella Shannon. *Hands that Built New Hampshire*. Brattleboro, Vt.: Stephen Daye Press, 1940.

Benes, Peter, ed. *Families and Children*. Boston: Boston University and the Dublin Seminar for New England Folklife, 1985.

Benes, Peter, ed. *Puritan Gravestone Art*. Boston: Boston University and the Dublin Seminar for New England Folklife, 1976.

Bishop, Robert. *American Folk Sculpture*. New York: E. P. Dutton and Company, Inc., 1974.

Bishop, Robert. *Folk Painters of America*. New York: E. P. Dutton and Company, Inc., 1979.

Black, Mary, and Jean Lipman. *American Folk Painting*. New York: Bramhall House, 1966.

Brewington, M. V. *Shipcarvers of North America*. Barre, Mass.: Barre Publishing Company, 1962.

Carter, Winthrop L. *George Boyd: The Shorebird Decoy: An American Folk Art*. Fayetteville, N.Y.: Tenant House Press, 1978.

Christensen, Erwin O. *The Index of American Design*. Washington, D.C.: National Gallery of Art, 1950.

D'Ambrosio, Paul S., and Charlotte M. Emans. *Folk Art's Many Faces: Portraits in the New York State Historical Association*. Cooperstown, N.Y.: New York State Historical Association, 1987.

Eaton, Allen H. *Handicrafts of New England*. New York: Harper and Brothers, 1949.

Ebert, John, and Katherine Ebert. *American Folk Painters*. New York: Scribner's, 1975.

Ericson, Jack T. *Folk Art in America: Painting and Sculpture*. New York: Mayflower Books, Inc., 1978.

Fitzgerald, Ken. *Weathervanes and Whirligigs*. New York: Clarkson N. Potter, Inc., 1967.

Glassie, Henry. *Pattern in the Material Folk Culture of the Eastern United States*. Philadelphia: University of Pennsylvania Press, 1968.

Hahn, Steven, and Jonathan Prude, eds. *The Countryside in the Age of Capitalist Transformation*. Chapel Hill, N.C.: The University of North Carolina Press, 1985.

Hemphill, Herbert W., Jr., and Julia Weissman. *Twentieth-Century American Folk Art and Artists*. New York: E. P. Dutton and Company, Inc., 1974.

Horwitz, Elinor Lander. *Contemporary American Folk Artists*. Philadelphia: J. B. Lippincott Company, 1975.

Larkin, Oliver W. *Art and Life in America*. 2d ed. New York: Hall, Rinehart and Winston, 1960.

Lipman, Jean. *Rufus Porter Rediscovered*. New York: Clarkson N. Potter, Inc., 1980.

Little, Nina Fletcher. *Country Art in New England 1790–1840*. 2d ed. Sturbridge, Mass.: Old Sturbridge Village, 1965.

Lord, Priscilla Sawyer, and Daniel J. Foley. *The Folk Arts and Crafts of New England*. 2d ed. Radnor, Pa.: Chilton Book Company, 1975.

Morison, Elizabeth Forbes, and Elting E. Morison. *New Hampshire: A History*. New York: W. W. Norton and Company, 1976.

Quimby, Ian M. G., and Scott T. Swank, eds. *Perspectives on American Folk Art*. New York: W. W. Norton and Company, 1980.

Ricco, Roger, and Frank Maresca. *American Primitive: Discoveries in Folk Sculpture*. New York: Alfred A. Knopf, 1988.

Rumford, Beatrix T., ed. *American Folk Portraits: Paintings and Drawings from the Abby Aldrich Rockefeller Folk Art Center*. Boston: New York Graphic Society, 1981.

Schlereth, Thomas J., ed. *Material Culture Studies in America*. Nashville, Tenn.: The American Association for State and Local History, 1982.

Vlach, John Michael. *Plain Painters: Making Sense of American Folk Art*. Washington, D.C.: Smithsonian Institution Press, 1988.

CATALOGUES

Armstrong, Tom, and Jean Lipman, eds. *American Folk Painters of Three Centuries*. New York: Hudson Hills Press, Inc., 1980.

Beck, Jane C., ed. *Always in Season: Folk Art and Traditional Culture in Vermont*. Montpelier: Vermont Council on the Arts, 1982.

Bishop, Robert, ed. *American Folk Art: Expressions of a New Spirit*. New York: Museum of American Folk Art, 1982.

Black, Mary. *What Is American in American Art*. Introduction by Lloyd Goodrich. New York: M. Knoedler and Company, Inc., 1971.

Bowman, Russell, et al. *American Folk Art: The Herbert Waide Hemphill, Jr. Collection*. Milwaukee, Wis.: Milwaukee Art Museum, 1981.

Buckley, Charles. *The Decorative Arts of New Hampshire 1752–1825*. Manchester, N.H.: The Currier Gallery of Art, 1964.

Cahill, Holger, ed. *American Folk Art: The Art of the Common Man in America, 1750–1900*. New York: Museum of Modern Art, 1932.

Cahill, Holger, et al. *Masters of Popular Painting: Modern Primitives of Europe and America*. New York: Museum of Modern Art, 1938.

Chittenden, Varick A., et al. *Found in New York's North Country: The Folk Art of a Region*. Utica, N.Y.: Munson–Williams–Proctor Institute, 1982.

De Natale, Douglas A. *Between the Branches: Folk Art of Delaware County, New York*. Norwich, N.Y.: Delaware County Historical Association and the Roxbury Arts Group, 1985.

Doty, Robert. *American Folk Art in Ohio Collections*. Akron, Ohio: Akron Art Institute, 1976.

Freidman, Martin, et al. *Naives and Visionaries*. Minneapolis, Minn.: Walker Art Center, 1974.

Garvan, Beatrice B., and Charles F. Hummel. *The Pennsylvania Germans: A Celebration of Their Arts: 1683–1850*. Philadelphia: Philadelphia Museum of Art, 1982.

Grave, Alexandra. *Three Centuries of Connecticut Folk Art*. Hartford, Conn.: Art Resources of Connecticut, 1979.

Hall, Michael D. *American Folk Sculpture: The Personal and the Eccentric*. Bloomfield Hills, Mich.: Cranbrook Academy of Art, 1972.

Hemphill, Herbert W., Jr., et al. *Folk Sculpture USA*. Brooklyn: The Brooklyn Museum, 1976.

Jones, Suzi, ed. *Webfoots & Bunchgrassers: Folk Art of the Oregon Country*. Salem: Oregon Arts Commission, 1980.

Kallir, Jane. *American Folk Art: People, Places and Things*. New York: Galerie St. Etienne, 1984.

Kind, Joshua. *Naive Art in Illinois: 1830–1976*. Chicago: Illinois Arts Council, 1976.

Larsen-Martin, Susan, and Louis Robert Martin. *Pioneers in Paradise: Folk and Outsider Artists of the West Coast*. Long Beach, Calif.: The Long Beach Museum of Art, 1984.

Lipman, Jean, and Alice Winchester. *The Flowering of American Folk Art 1776–1876*. New York: Viking Press, 1974.

Little, Nina Fletcher. *Paintings by New England Provincial Artists, 1775–1800*. Boston: Museum of Fine Arts, 1976.

Livingston, Jane, and John Beardsley. *Black Folk Art in America 1930–1980.* Jackson, Miss.: University Press of Mississippi, 1982.

MacDowell, Marsha, and C. Kurt Dewhurst. *Michigan Folk Art: Its Beginnings to 1941.* East Lansing, Mich.: Michigan State University, 1976.

Mason, Benjamin L., et al. *An American Sampler: Folk Art from the Shelburne Museum.* Washington, D.C.: National Gallery of Art, 1987.

Metcalf, Eugene, and Michael D. Hall. *The Ties that Bind: Folk Art in Contemporary American Culture.* Cincinnati, Ohio: The Contemporary Arts Center, 1987.

Page, John F. *The Decorative Arts of New Hampshire: A Susquicentennial Exhibition.* Concord, N.H.: The New Hampshire Historical Society, 1973.

Rhodes, Lynette I. *American Folk Art: From the Traditional to the Naive.* Cleveland, Ohio: The Cleveland Museum of Art, 1978.

Rumford, Beatrix. *Folk Art in America: A Living Tradition.* Atlanta: The High Museum of Art, 1974.

Savage, G., N. Savage, and Esther Sparks. *Three New England Watercolor Painters.* Chicago: The Art Institute of Chicago, 1974.

Scalora, Sal. *"Gifted Visions": Contemporary Black American Folk Art.* Nashua, N.H.: Nashua Center for the Arts, 1989.

Tillou, Peter H., et al. *Nineteenth-Century Folk Painting: Our Spirited National Heritage.* Storrs: The William Benton Museum, The University of Connecticut, 1973.

Wadsworth, Anna, ed. *Missing Pieces: Georgia Folk Art 1770–1976.* Atlanta: Georgia Council for the Arts and Humanities, 1976.

Welsh, Peter C. *American Folk Art: The Art and Spirit of a People.* Washington, D.C.: Smithsonian Institution, 1965.

PERIODICALS

Brooke, David S. "Recent Acquisitions." *The Currier Gallery of Art Bulletin* (1976): 24–27. A discussion of the Jones Tavern Sign and Portrait of Levi Jones is included in this article.

Courtney, David W. "Two Centuries of American Folk Art." *Arts Magazine* 58 (March 1984): 126–128.

Doty, Robert. "A Portrait of Bartholomew Van Dame by Joseph H. Davis." *The Currier Gallery of Art Bulletin* (1984): 11–16.

Hall, Michael D. "The Problem of Martin Ramirez: Folk Art Criticism as Cosmologies of Coercion." *The Clarion* (Winter 1986): 56–61.

Isaacson, Philip. "Records of Passage: New England Illuminated Manuscripts in the Fraktur Tradition." *The Clarion* (Winter 1980/81): 30–35.

Kellogg, Helen. "Found: Two Lost American Painters." *Antiques World* 1 (December 1978): 36–47.

Lipman, Jean. "American Primitive Portraiture." *The Magazine Antiques* 40 (September 1941): 142–144.

Little, Nina Fletcher. "Indigenous Painting in New Hampshire." *The Magazine Antiques* 86 (July 1964): 62–65.

Mankin, Elizabeth R. "Zedekiah Belknap." *The Magazine Antiques* 110 (November 1976): 1056–1070.

Metcalf, Eugene W. "Black Art, Folk Art, and Social Control." *Winterthur Portfolio* 18 (Winter 1983): 271–289.

Metcalf, Eugene W. "Myths in American Folk Art History." *Maine Antique Digest* (November 1986): 10B–11B and (December 1986): 9A.

Metcalf, Eugene W. "The Problem of American Folk Art." *Maine Antique Digest* (April 1986): 34A–35A.

Miele, Frank J., ed. "Folk, or Art? A Symposium." *The Magazine Antiques* 135 (January 1989): 272–287.

Randall, Don. "Moses Connor, Jr.: Illustrator, Teacher, Citizen." *The Eastern Antiques Reporter* 2 (February 1984): 1.

Randall, Don. "Sally Hodgdon, N.H. Watercolorist." *The Eastern Antiques Reporter* 1 (November/December 1983): cover, 8.

Schorsch, Anita. "Mourning Art: A Neoclassical Reflection in America." *The American Art Journal* 8 (May 1976): 4–15.

Wendell, William G. "History in Houses: The Macpheadris-Warner House in Portsmouth, New Hampshire." *The Magazine Antiques* 87 (June 1965): 712–715.

Wiggins, David Bradstreet. "New England Wall Painting." *Antique Collecting* 3 (July 1979): 21–25.

Winchester, Alice, ed. "What Is American Folk Art? A Symposium." *The Magazine Antiques* 57 (May 1950): 355–362.

Photography credits: cover illustration, color plates I, VII, and VIII, and figures 3, 4, 10, 19, 20, 23, 24, 31, 33, 36–38, 41–43, 50, 53–60, 64, 68, 71, 78, 80, 81, 84–89, 91, and 92 by Bill Finney; color plates IV, V, and VI and figures 12, 22, 26–30, 35, 39A–D, 44, 46–49, 62, 65, 69, 70, 73–76, 79, 93, 94, and 96–102 by Gary Samson, Media Services, University of New Hampshire; figures 1 and 2 by Daniel and Jessie Farber; figures 14, 15, and 52 by Henry E. Peach; figure 32 by Alexander Photography; figure 51 by Mark Sexton, Peabody Museum of Salem.

Designed by Martha de Lyra Barker,
University Publications, University of New Hampshire
Edited by Shirley J. Ramsay, Director,
University Publications, University of New Hampshire

Composed by Monotype Composition Company in Meridien
Printed by Penmor Lithographers on Mohawk Superfine and Potlatch Vintage Velvet
Bound in Potlatch Vintage Velvet